for James, Phoebe and Brogan

THE ART OF SPORTS PHOTOGRAPHY

Marc Aspland

PRESTEL

MUNICH · LONDON · NEW YORK

Canon

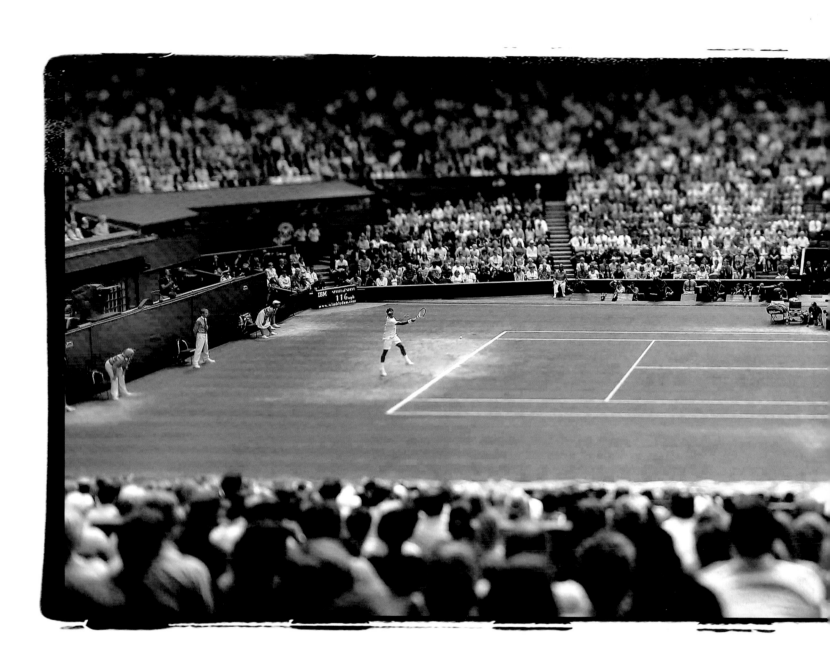

CONTENTS

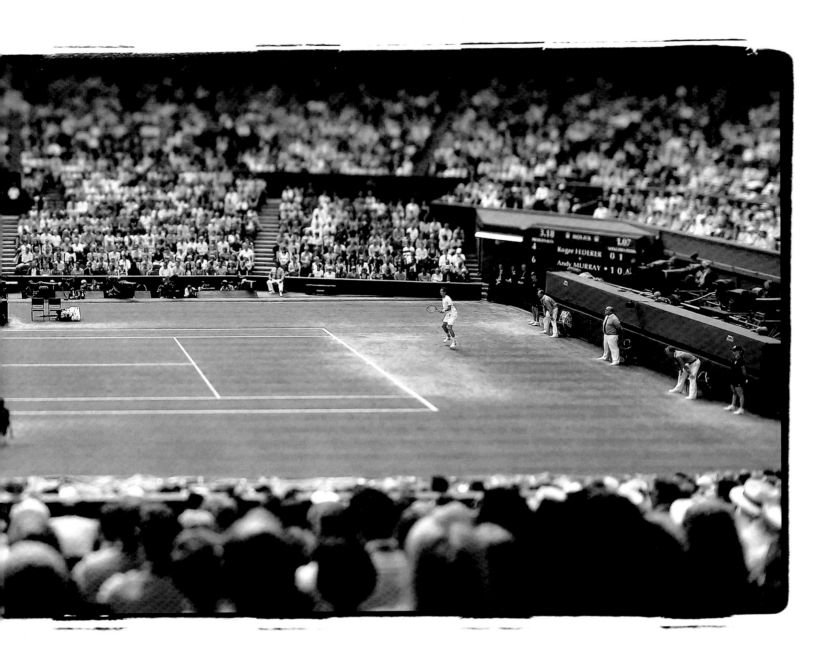

Roger Federer vs Andy Murray on Centre Court at the All England Lawn Tennis Club, Wimbledon Championships, London, 7th July 2012.

FOREWORD ~ JONNY WILKINSON

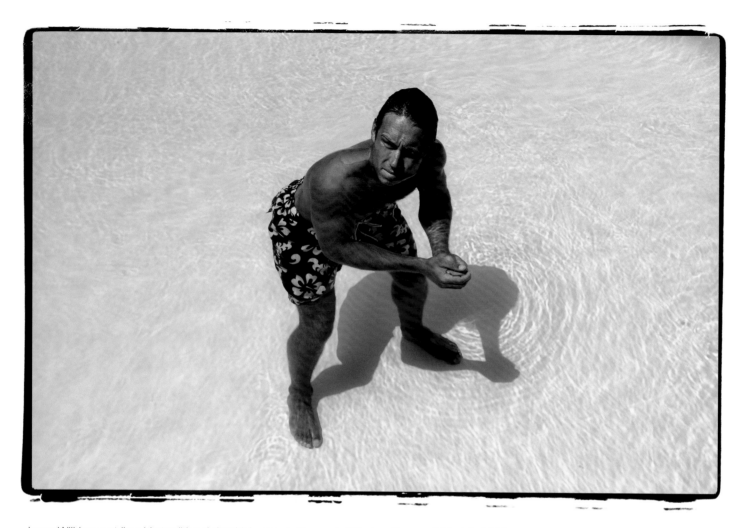

Jonny Wilkinson strikes his traditional dropkick pose in the pool at Toulon, France, 30th July 2009.

As a professional sportsman some days, in fact most days, the last thing that you feel like doing is posing in front of a camera; especially when you naturally feel awkward and embarrassed and a little bit like you are being set up!

Marc and I started a working relationship when I began writing for *The Times* fairly early on in my career. We had a great partnership – me, Marc and our journalist teammate Owen Slot – embarking on a roller-coaster journey through many interesting situations over several years. During those years, and through so much time together, I learned to see things more than a little bit differently.

What you see is what you get with Marc. From the very first minute you meet him, he lets you know what he is all about by

the way he lives and loves his work. Perhaps I would have been slightly intimidated by this side of him when I was a lot younger, I can't remember, I'm too used to him and way too fond of him now.

Marc and I went through the 2003 Rugby World Cup together – everything, including that long build-up and the emotional aftermath. That was quite something. We then endured four of the most emotionally turbulent years of my life during which I was plagued with injury problems. Marc was there again for my big move abroad to the South of France and Toulon in 2009. Finally, I had a truly life-changing moment at the end of 2011, when I waved goodbye to international rugby – and he was there for that too and I wouldn't have had it any other way.

That's not to say it has always been sweetness and light between the two of us though, as an incident at the rugby World Cup in 2003 forever reminds me.

In the week before the final - it was the Wednesday - Owen and I chatted our way through a big, important column which, with me being incredibly reserved and self-conscious, was probably going to be very boring. Owen mentioned that he needed a photo to spice it up. No chance - I thought. I had no inclination whatsoever to leave the hotel to have my picture taken; I was petrified about what all the England supporters would think and do, the pressure it would put me under. I just thought, I can't handle this before such a big game. But Marc had an idea. Of course he did. He had seen an 'ideal' place which was quiet, completely hidden away and, of course, was going to look great in a photograph.

So down we went, in the prime midday heat, to the very centre of the largest and most frequented beach in Manly for our 'private shoot'. Throughout the entire ordeal, I gritted my teeth and glared at him through his camera, trying to shatter the lens with my dark, hostile thoughts.

Five and a bit years later, in early 2009, I had hit an all-time low with my knee injury and was beginning to fear that the end may be in sight. I was sent on a trip to Vermont to spend three weeks with a miracle-working rehab specialist; there was a lot hingeing on that trip. So out came the boys to join me. They sniffed a good story, some great photos and a little bit of skiing.

Marc had another of his great ideas. It involved us all going up to the top of the highest mountain and taking in the view. And what a view it was too - if only I had had a chance to see it. There I was, at the top of the slope trying to protect my bad leg whilst being cursed and knocked out of the way by disgruntled skiers. Nice one, Marc! I remember that one also being a fairly stern-faced, angry shoot.

And then there's the swimming pool shot you see here. During a relaxed afternoon in the Toulon sunshine, the three of us were hanging out by the pool. Marc raced off to fetch his camera after seeing me in the water saying that he had another idea. I do not do the 'top off' shots, by the way, and he knows this better than

anyone. Nevertheless, he told me that this one would be really good. 'Just trust me!', he says. In those words lies his greatness and, in my opinion, the secret behind his phenomenal photos.

From the outset, Marc seemed to 'get' me. Our personalities in some respects could not be further apart, but he still was able to empathise and understand where I was coming from and deduce what I was thinking almost immediately. When he integrates these uncoachable gifts in with the techniques you can teach (but probably not master to his level), he has the perfect blend of skills to create intensely truthful images.

The ability to see through my eyes, other players eyes, the ability to live inside the mind - albeit briefly - of the performers, to think how they are thinking and feel the same emotions, is what sets his angles and his focus on target. It is the same thing which directs him uncannily towards being in exactly the right place at exactly the right time almost every time.

His passion is a rare delight in this day and age when enjoyment and love of a trade can quickly slip down the priorities list beneath money and fame. His infectious energy and positivity is what keeps coaxing me to these stupid places that I don't want to go to, to have photographs taken which I'm totally unsure of. His brilliance is what helps me to realise that maybe I really actually had fun after all; his photos let me know that I should never have doubted him in the first place; and his qualities as a great human being are what bring it all together.

With the press of a button, Marc Aspland gives me memories I can hold in front of me; memories which somehow end up being better than the fabulous experiences they depict. He manages to transpose events we all wish we had been there to experience into things we can still see and feel for ourselves just as if we had been present.

I could go on, but his amazing book of photographs here will happily do the rest.

A NEWSPAPER'S ALCHEMIST ~ BY OLIVER HOLT

It was probably the first football job we did together – Marc Aspland and I. It didn't yield anything as spectacular as the wonderful images from the world of sport that grace this beautiful book, but it was a crash course for me in the way that masters of their art such as Marc have to fight for the right to capture the essence of their subject.

Back then, at the end of the 1990s, it was about the closest that football writers and photographers, like me and Marc, got to entering a war zone. We had organised a meeting with the Manchester United captain, Roy Keane, at the club's old training ground, The Cliff. Keane didn't do many interviews and, even then, he had a reputation as a rather intimidating subject, so the project was not without tension from the outset.

We had neglected to mention the interview and photo shoot to Sir Alex Ferguson, United's aggressively controlling manager, who was on the verge of making the great achievements that were to establish him as the most successful boss in British football history. We had decided that discretion, secrecy and, let's be honest, downright cowardice were the best options where Ferguson was concerned. Going through the gates at The Cliff felt, as it had felt to many before us, like entering the lion's den.

The interview was fine. Keane had already perfected his unsettling stare and his answers were sometimes confrontational. But they were better for that and it was something of a coup to have got some time with him. Now it was time for the pictures.

Keane appeared to grow slightly agitated at this point, which was unnerving for us. He did not want to pose for the pictures where Marc suggested because he said that Ferguson might see us. Nobody really wanted that. So Marc suggested they dart round the corner of the wall of the gym and that he take some portraits against a backdrop of red brick, away from Ferguson's prying eyes.

Keane agreed. He posed for a couple of minutes. Job done. It wasn't ideal, particularly not for Marc, but it was a prime example of how the great sports' photographer often has to act as a newspaper's alchemist – magically turning a limited opportunity into a striking image. Capturing the moment in the heat of intense pressure can be a different discipline to the one displayed by many of the stunning, beautifully composed photographs shown in this book but, under the circumstances, the results can be just as impressive.

Sometimes, as a reporter, you can feel that the photographer is getting in the way. Either you are worried that he might say the wrong thing, strike a discordant note, put the interviewee on edge. Or you wonder whether the prospect of the photos being taken and the very presence of the photographer might put the subject on edge.

That never happened with Marc. In fact, the opposite was true. Part of his talent is being able to put his subjects at ease. It was always a massive advantage to have Marc along on a job because the interviewee was more likely to feel relaxed by the time the conversation began. It is part of a reporter's skill-set to be gregarious, to get on with people. It is the same with sports' photographers and this one in particular.

Marc and I worked with a lot of footballers while I was at *The Times*. In the mid-nineties, big interview features with players were less common than they are now, but Marc's stunning portraits of men like Robbie Fowler and Michael Owen, both taken in the alleyways around Anfield, helped to change that.

They popularised the idea that interviews could be sold to readers as complete packages, the words illustrated with remarkable portraits, which could have stood alone and were often as compelling and as revealing as the 1,000 words or so that accompanied them on the page.

One of the most interesting jobs we ever did together was something that allowed us both to move into hard news reportage, an area with which we were blissfully unfamiliar. When we went to Istanbul to cover a Chelsea match against Galatasaray in October 1999, we took a day out to travel the hundred kilometres or so to the east to look at how football had been affected by a terrible earthquake that had ravaged the country several weeks earlier.

The night before we left for Izmit, the hotel we were staying in on the banks of the Bosphorus juddered gently to an aftershock. The

next morning, we agreed a price with a taxi driver to take us to the town that had been worst hit. There was a Turkish top flight football club there, Kocaelispor. Some of the players had lost loved ones in the disaster; and a couple of them had been injured themselves.

The driver did not know how far he would be able to take us, but two months had passed since the quake and rescue work was well under way. Roads had been made passable again, but as we entered the town centre, the extent of the devastation was clear.

One house, three storeys high, was leaning over at twice the angle of the Leaning Tower of Pisa. You had to take a second look to realise that the only thing that was stopping it from collapsing was a brave, solitary lamppost propping it precariously up. Many other buildings had been flattened, their occupants crushed inside. More than 17,000 people had died in the catastrophe.

We drove on through the town, asking directions to the football stadium all the way. In the end, we found it. It was damaged. Parts of it had been reduced to rubble but most of it was still standing. Indeed, it had become one of the centres of the recovery effort. It was not a place for football any more but a makeshift hospital for those who had been injured when the quake struck.

Makeshift tents covered part of the pitch and military vehicles were parked around the touchlines. The goalposts were still in place and we saw some kids kicking a ball around. They were the orphans, the displaced and destitute of the disaster but for a time at least, they had smiles on their faces as they chased a ball around. Marc joked with the lads for a while, then took some pictures. Before we left, these kids who had endured so much hardship and heartbreak, posed for him in a line, grinning at the camera.

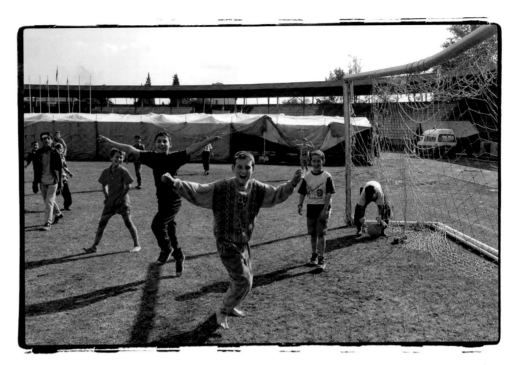

Children play at the emergency triage centre on the Kocaelispor football ground following the İzmit earthquake, Ismet Paşa Stadium, Turkey, August 1999.

I have that picture on my wall at home. Like many of the pictures in this book, it is an example of how Marc's photography often escapes the parameters of sport, even when it is about sport. It transcends the action to take in the indomitability of the human spirit; the quest for perfection and fulfilment; and reflects the breathtaking beauty of the world around us.

That's what I love about Marc's portrait of England rugby hero Jonny Wilkinson in this collection. The image shows him standing in a swimming pool, his arms stretched out in front of him in that rather unnatural, forced posture that he assumes as he is about to take a kick. It says as much about Jonny as any piece could. You look at it and you see his obsession, his devotion, his commitment and his restlessness, the search for perfection that gnaws at him and invades his existence wherever he is – whether on holiday or on the playing field.

That's what I love about the picture of that perfect rainbow arcing over the course at Celtic Manor during the 2010 Ryder Cup in south Wales. What a weekend that was! A weekend when the elements battered the golf to a standstill before delivering a blue

9

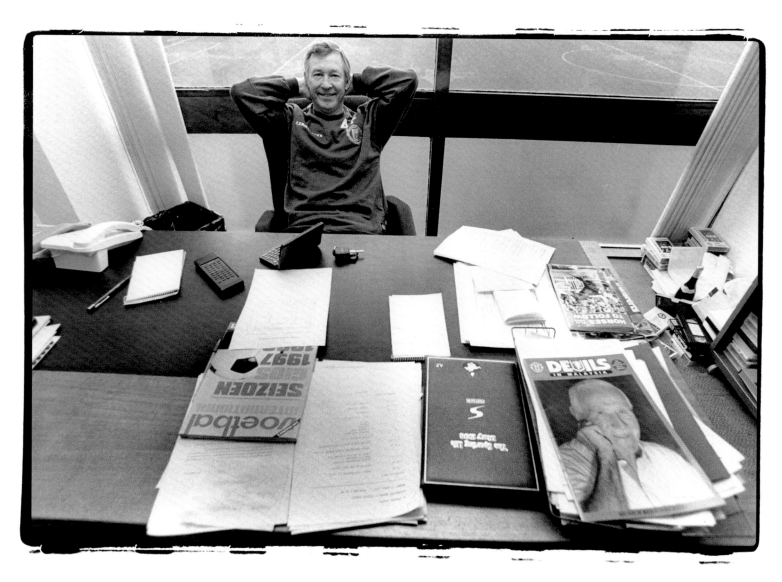

Sir Alex Ferguson takes it easy behind his desk at Old Trafford.

sky Monday and another day of almost unbearable drama in the competition.

Often hearing a song takes you back to a place in time. I listen to 'Lily, Rosemary and the Jack of Hearts' by Bob Dylan and I'm taken back to a little lawn outside my room at college, sitting there with a friend on a lazy summer's day, talking about things that seemed important and vital then, enjoying being young and suddenly filled with the thrill of so much which lay ahead.

Photographs do that more too but more overtly. They guide you back to your memories more directly. They show you an element of what you remember and rush you back there. The vision of Celtic Manor dominated by a rainbow does that vividly for me. It carries me back to one of the best weekends of sport I have ever witnessed.

That rainbow and that course, they're a trigger for memories of the deluge that fell upon south Wales that weekend, of the rivers of water that ran down the fairway towards the eighteenth green, of seeing the areas behind the ropes turn into quagmires, of the public's commitment to watching sport, even in such dreadful conditions.

But that rainbow in that image symbolises something else, too, about that weekend and about sport in general. Somehow, there is always a positivity about Marc's work that hints at sport's ability to overcome adversity; a positivity that affirms sport's penchant for providing an escape from everyday life; a positivity that makes so many of us gravitate towards it.

So, after the deluge at Celtic Manor, after all the gripes about the lunacy of staging the Ryder Cup in south Wales in the autumn, the rainbow appeared and the gripes gave way to the drama of that crisp, clear final day when everything hinged on the last match between Graeme McDowell and Hunter Mahan and, as the ropes disappeared and a huge crowd massed on the fringe of the seventeenth green, Europe, against all the odds, prevailed.

I have other pictures taken by Marc on my walls at home, ones that didn't make it into this book. There's one of the indigenous Australian women's 400m champion Cathy Freeman, taken a

few moments after she crossed the line at the Sydney Olympics to claim the gold medal that the whole nation had been willing her to win. She is sitting on the track in the green body suit that she wore for those Games, looking utterly exhausted, both mentally and physically. We had all wanted her to represent something more than an athlete. We had wanted her to salve some of the wounds in Australian society and that picture shows how the pressure of playing that role had nearly defeated her.

Even though I know that newspapers are fighting to adapt to the changes in technology that have revolutionised the market in the last ten years, even though they are searching for a way to evolve, even though more and more people are reading online and on tablets, I know there will always be a market for the written word and that in one form or another, newspapers, like books, will find a way to survive.

And, looking through the images taken by Marc, thinking back to all the jobs we did together, all the work he has done with journalists such as Matt Dickinson, Simon Barnes and Owen Slot, it underlines the fact that the power of sports' photography is not diminishing. It is increasing.

Photographs like the ones in this collection are becoming more and more powerful and more and more important. The world is moving faster and faster. There is less and less time for reflection. Pictures freeze the maelstrom. They bring clarity to the rush. They capture the essence of sport's struggle and reveal its triumph in an instant.

So bring on the best that sport has to offer. And the rainbows and the back streets and the football clubs that provide comfort in times of tragedy and the heroes who never stop striving. You can find many of them here, captured in their majesty for all time, or perhaps just until a new generation leaps higher and runs faster in front of the lens.

PREFACE ~ MARC ASPLAND

photograph: Simon Bruty, Sports Illustrated

A few of my Fleet Street photographer colleagues might recoil at the title of this book. The only explanation I can offer to them is that The Art of Sports Photography is the best interpretation of the way I see pictures. During my career, right from when I first picked up a camera as a kid, I felt that photography came naturally. I had found an art form, which allowed me to express myself. I recognise how fortunate I am that photography found me and it soon became more than a hobby. It became an obsession.

Even at photojournalism college in Sheffield, I was warned not to return for a new term as I was just too 'arty-farty'. At my first newspaper, as a junior photographer, I soon learnt that cheque presentations and golden wedding anniversary pictures for the local rag needed to be photographed in a certain way (which was not the way I wanted to photograph them).

I had my own ideas on photography and I am extremely fortunate that, on my journey, I could also be touched by the brilliance of other photographers. Seeing the remarkable black and white images by legendary British Sports photographer Chris Smith which graced The Sunday Times gave me an early appreciation of the type and style of photography which I longed to emulate. I believe all photographers constantly look and learn from how others have captured a moment, and this is certainly true of me. Being a newspaper man my whole career, I have had a daily diet of the most remarkable images to admire.

If I can share in words a snapshot in time, I would tell of a moment when I was a young man in a hurry just trying just to get a toe in the door of The Times newspaper. Being the fourth or fifth choice freelance photographer, I was assigned a football match on Saturday afternoon and, by a strange chance, ended up sitting next to Chris Smith behind the goal. As a Saturday used to be a 'non-edition day' for us daily newspaper photographers, I made my way back to the old darkrooms shared by The Times and Sunday Times to process my black and white films. After collecting my films from the drying cabinets and taking myself off to the furthest light-boxes to view my negatives - as far away as possible from the hustle, noise and laughter of the many great photographers present - I began to edit from frame 1A to frame 36. With my eye on a magnifying glass, clipping almost every other frame to be printed I began to feel how remarkably well I had shot the match. Rolls two and three followed with a growing feeling of my own greatness, until I received a gentle tap on my shoulder and, looking up, found Chris Smith holding three rolls of film. He politely explained, 'I am sorry young man, but I think you will find those are mine and these are yours.' We swapped films and I recognised immediately what a long way I still had to go.

Fast forward to the halcyon days I spent with Oliver Holt, then Chief Sports Writer of The Times. We were fortunate that the old broadsheet pages offered us the canvas to produce a weekly interview. While Oliver would be afforded an hour of conversation, as all photographers invariably are, I would usually be hurried in to take photographs in the last ten minutes. My days at the Watford Observer stood me in good stead. Back then, I would have even less time to photograph my subjects before rushing off to the next assignment – in one case, I had five minutes to photograph a couple who had spent fifty years together. Listening to Oliver's interviews, trying to understand the footballer or athlete and what made them tick, gave me an insight into how I could capture their essence in an image.

My favourite images would not necessarily feature famous stars or World Cup finals. I have very few of my own pictures on the wall at home, but one of them is of a group of children orphaned by a devastating earthquake in Turkey in 1999. As Ollie was talking to the Red Cross, I set up a World Cup Final between Turkey and

England on the barren pitch. An early digital camera became an international language, as I was able to show the orphaned and injured kids the images on the back of the camera. It then came down to a penalty shoot-out and the image you see on page 9 happened. It is a not a Pulitzer Prize winning picture but, for me, it sums up everything great about the joy of both childhood and photography. It is a moment in time, an expression of life.

This is how Henri Cartier-Bresson, the father of modern photojournalism, described his concept of *The Decisive Moment,* 'Photography is not like painting. There is a creative fraction of a second when you are taking a picture. Your eye must see a composition or an expression that life itself offers you, and you must know with intuition when to click the camera. That is the moment the photographer is creative. Oop! The moment! Once you miss it, it is gone forever.'

I will admit that I have missed many great sporting moments that have gone forever, but I do believe my style of sports photography is rather more 'defining' than 'decisive'. Unlike the interviews conducted with my *Times* colleagues where I am able to impose my photographic style, it is live sport where I thrive. The moment in sport, once missed is gone forever. I cannot ask Jonny to retake that drop goal against Australia in 2003 because a green and gold shirt flashed in front of my lens at the decisive moment but, by searching out and seeing my own moments in time, I try to capture a defining moment, which sums up the whole match, the victory, the loss, the joy and the disappointment. If that drop goal was decisive, then the very last picture on page 143 of England captain Martin Johnson with his bear-like paws around the shoulders of Jonny Wilkinson is defining. And, rather like Jonny, I have been practising and refining my craft every day.

Similarly, I did not capture the decisive knock-out punch by Floyd Mayweather Jr against Ricky Hatton in Las Vegas in 2007, but the image of Ricky staring into the floodlights of the MGM Grand reminds me that, perhaps, I just might have emulated Chris Smith's celebrated picture of Barry McGuigan staring defeat in the face from his corner stool against Steve Cruz in 1986 - his eyes telling the whole sorry story. For me, fine sports photography

does not have to be about capturing the decisive moment but more about a picture telling a thousand words.

I believe it is the way we see pictures, which defines us as photographers. Having an eye for the details or taking a panoramic scene makes us see differently as photographers. The Sports Editor of *The Times* will be inundated by thousands of images of, say, the 100 metres final at the Olympics but he will want to see how I have captured the event - and this is true at each and every sporting occasion to which I am assigned. By being unique, my images offer my newspaper its own identity and an instantly recognisable style of photography.

I have been fortunate to use Canon cameras my whole career, from my very first 35mm SLR camera, a beautiful Canon F1, to the ultra-modern and sophisticated Canon EOS 1D-X digital cameras I use today. The equipment has changed beyond recognition during my career and an image taken at 1/8000th of a second can be transmitted directly from my Canon EOS 1D-X to the offices of *The Times* from almost anywhere in the world in a matter of a few seconds. Speed of filing images is now the priority but I believe quality will always surpass quantity in the race to have a picture published. The actual practicalities of my job have not changed - sitting pitchside, seeing and finding pictures of the match unfolding in front of me has not changed but now we live in an era when deadlines are gone in minutes, as our website demands almost instant images. At the World Cup in Brazil I will be filing my pictures directly from my camera to London and the website will show pictures taken just seconds before.

My job has changed in many ways but the art of great photography passes from one generation to the next, each of us trying to pick up tips and techniques from both our predecessors and those around us whom we admire, to which we can add our own vital style. My career has spanned far too many years to count now; I am always learning and refining my craft. My highlights range from the kids in Turkey to the picture I will take tomorrow. I sincerely hope you enjoy this collection and see something in the way I see pictures.

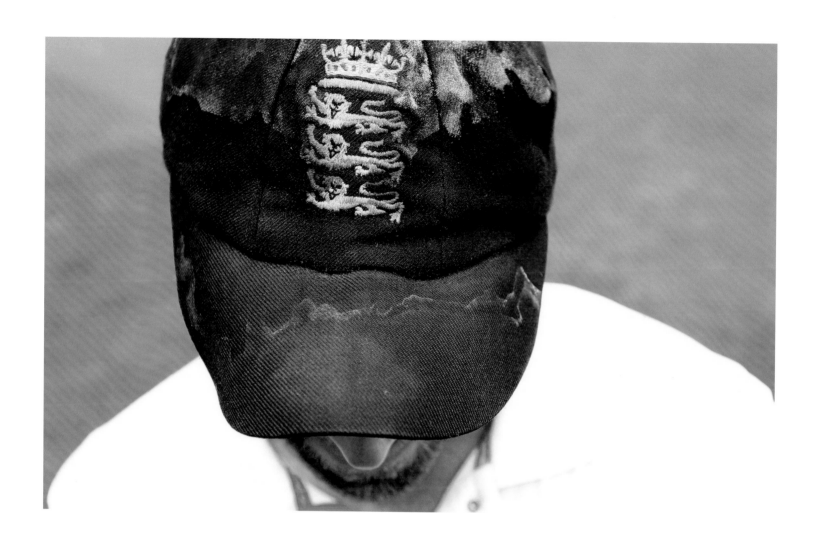

Matt Prior shows salt sweat patches on his England cap after the final day of the Ashes series, January 2011.

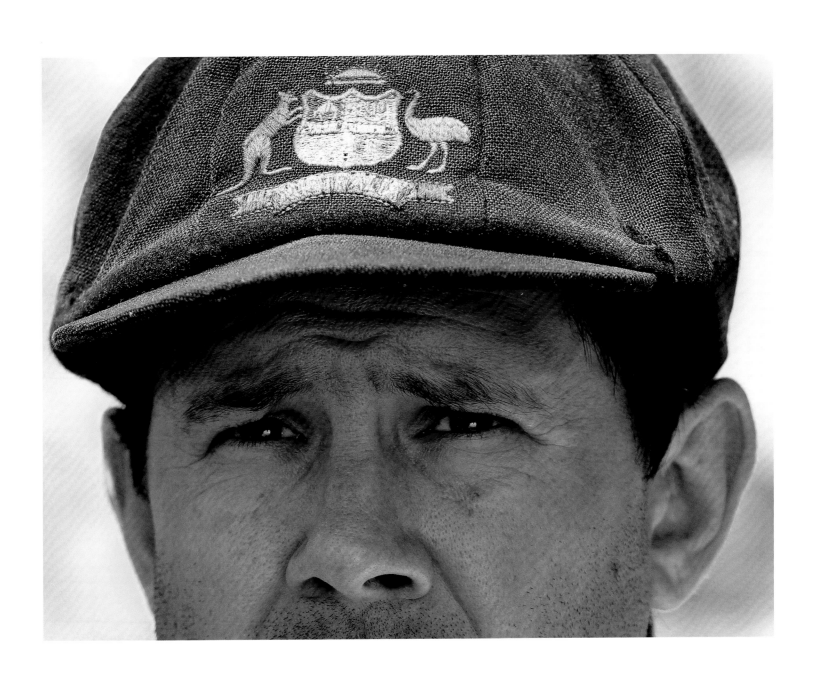

Australia captain Ricky Ponting on the first day of first Ashes Test match at the Gabba, Brisbane, Australia, November 2010.

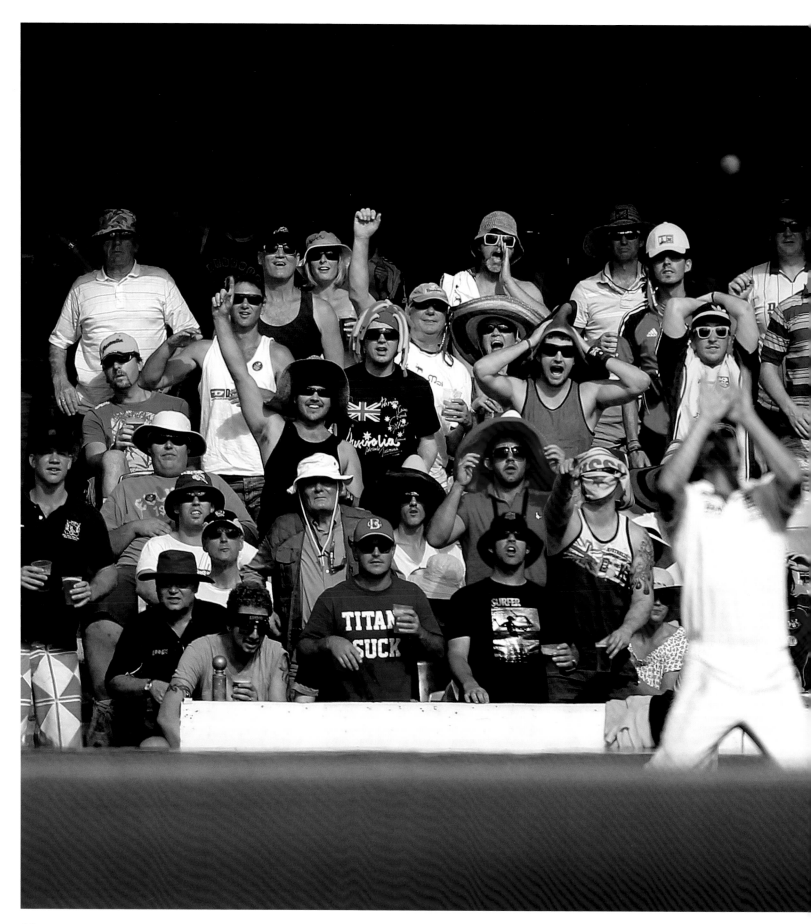

Alastair Cook of England holds his nerve finally to take the catch for the valuable wicket of Mike Hussey as the home and away fans behind him show their divergent reactions to the unfolding drama at the Gabba during the first Ashes Test in Brisbane, November 2010.

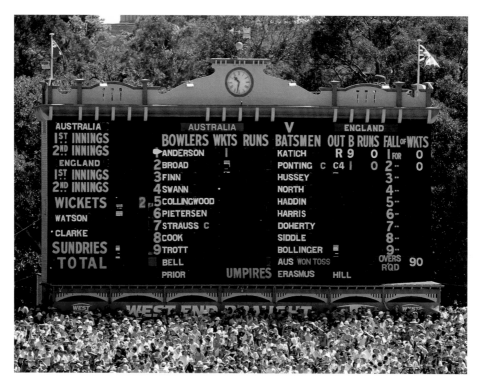

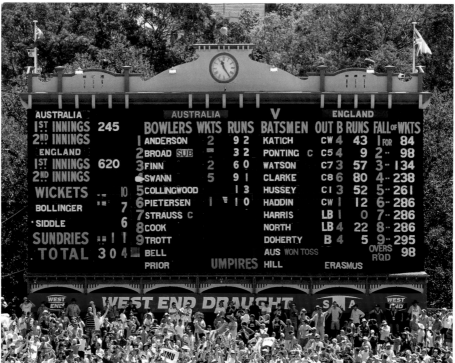

Top: Just three minutes into the first day of the second test match, the scoreboard shows Australia two wickets for no runs in the first over, Adelaide Oval, Adelaide, Australia, 3rd December 2010.

Bottom: After five captivating days, the final numbers light up the old scoreboard at the Adelaide Oval showing England's remarkable victory in the second Ashes Test, 7th December 2010.

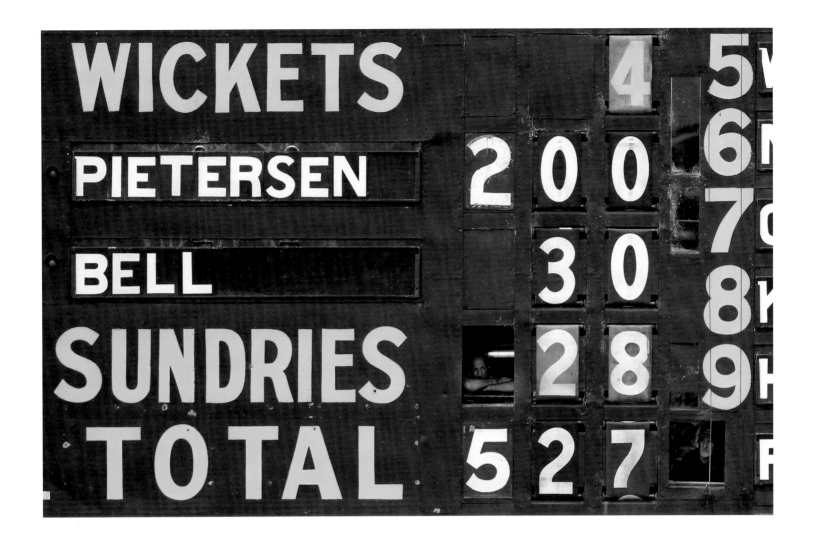

Local scoreboard operators look decidedly unimpressed as Kevin Pietersen chalks up his double century to take England to a total of 527 at the Adelaide Oval during the second Ashes Test, 6th December 2010.

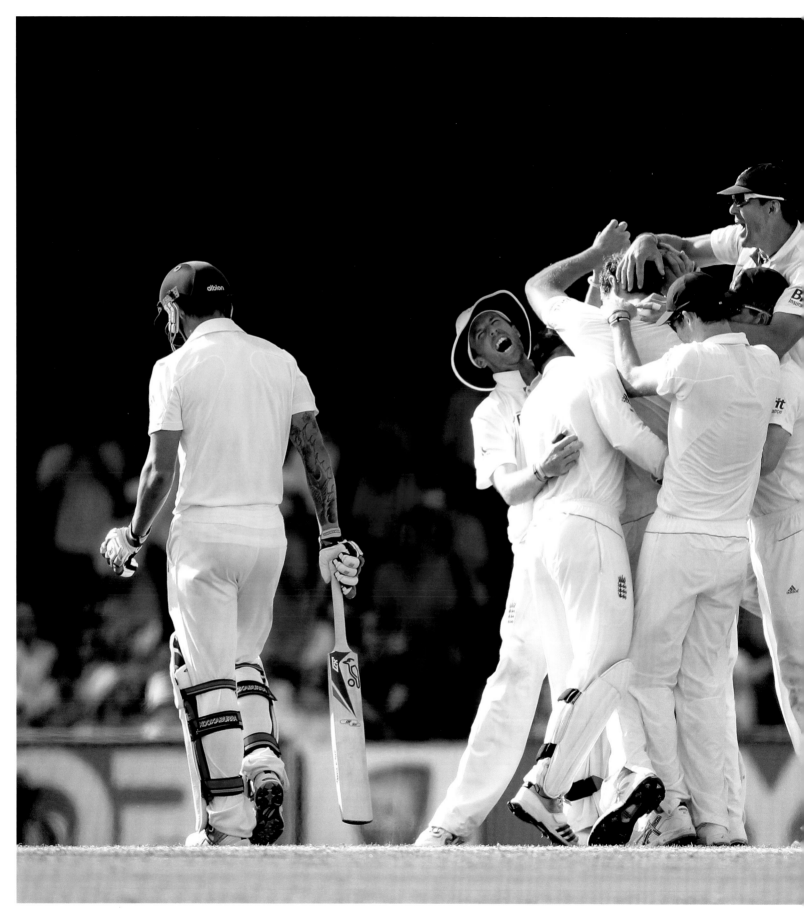

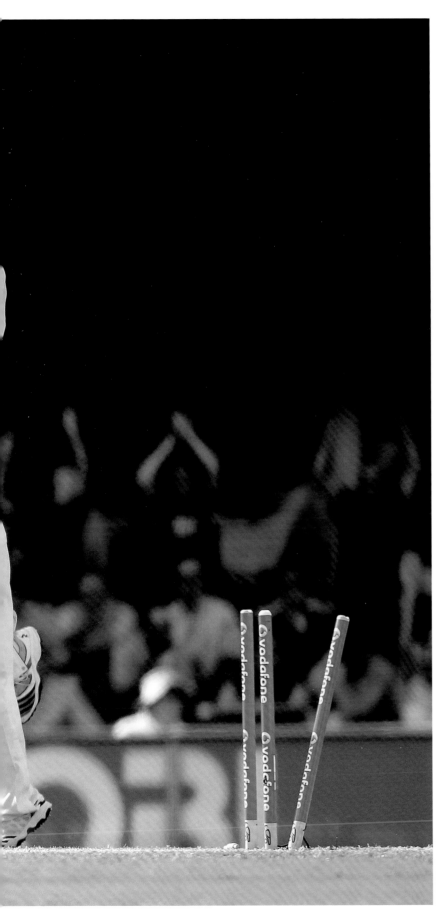

England jump for joy after Chris Tremlett takes the wicket of Mitchell
Johnson for a duck in the second innings at the Sydney Cricket
Ground during the fifth Ashes Test match, Sydney, 6th January 2011.

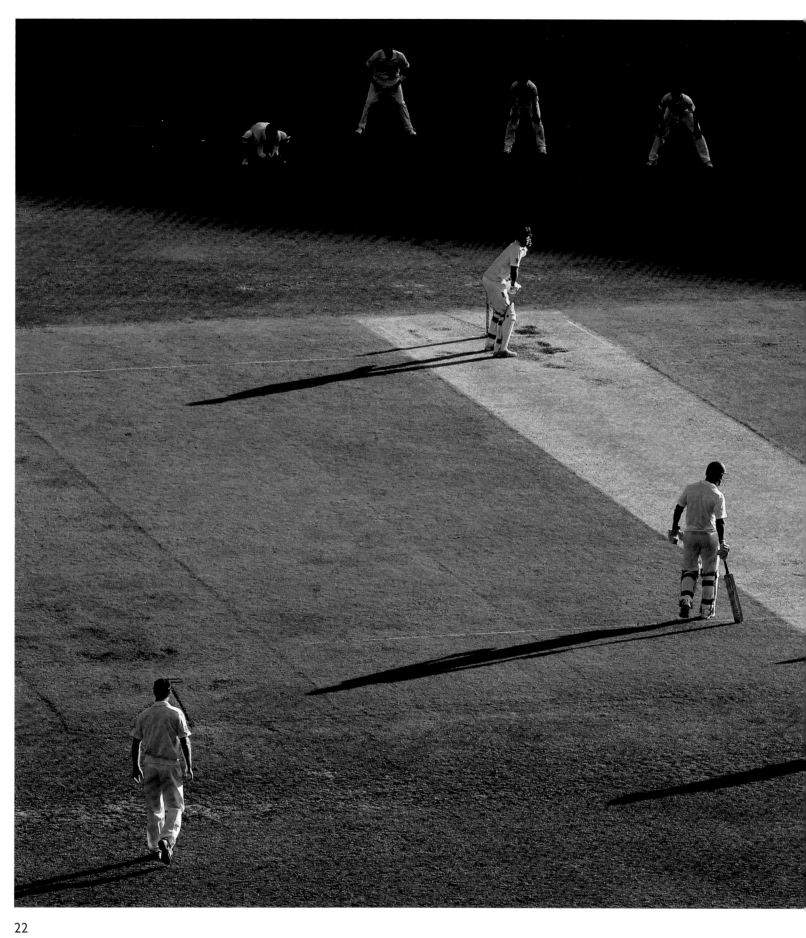

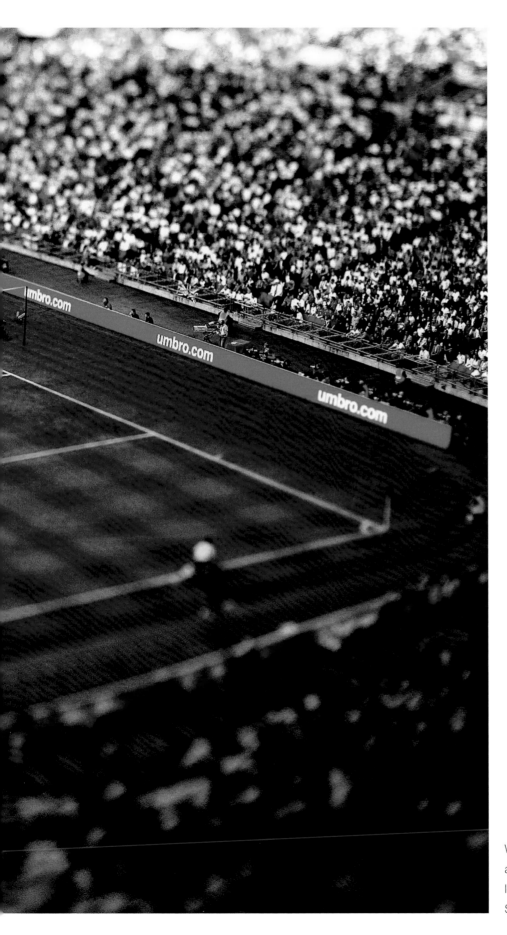

World Cup Qualifier, England vs Kazakhstan, taken from a television gantry using a specialist Canon tilt-and-shift lens that produces an image which makes it look like Subutteo, Wembley Stadium, 10th December 2008.

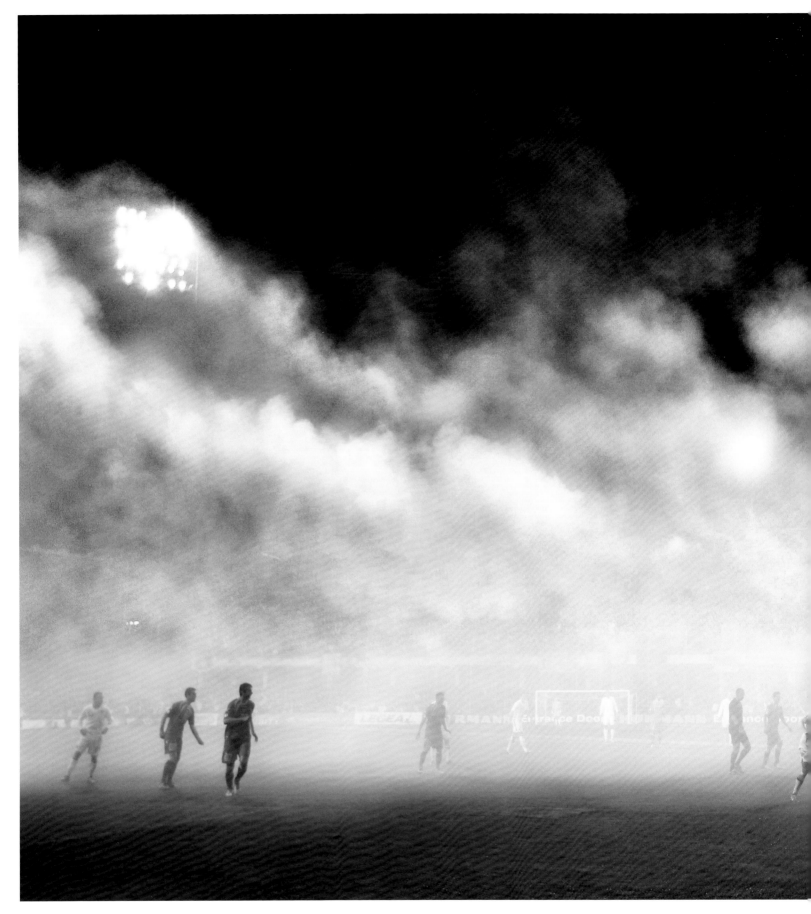

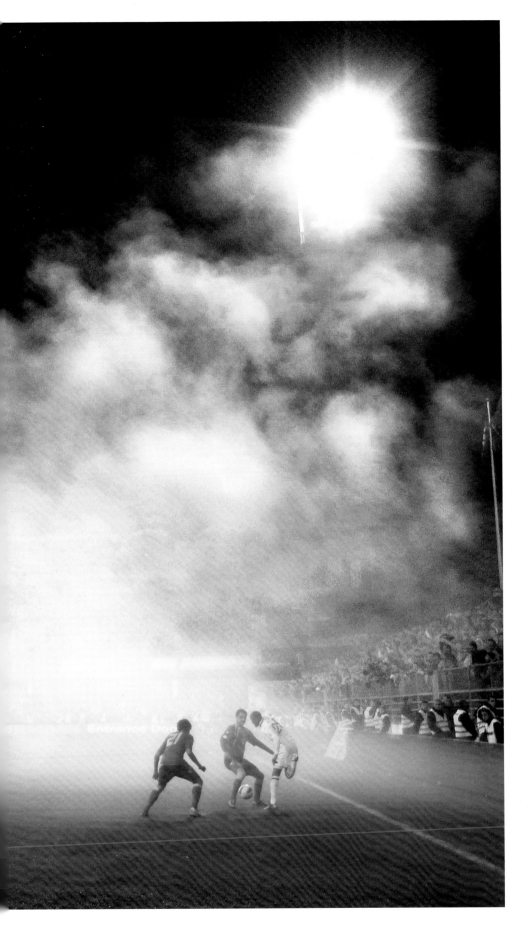

Smoke from a flare produces an eerie atmosphere in the already highly-charged Podgorica City Stadium during Montenegro vs England, 26th March 2013.

Next page: England train at Wembley Stadium ahead of their UEFA Euro 2012 Qualifier against Montenegro, 10th October 2010.

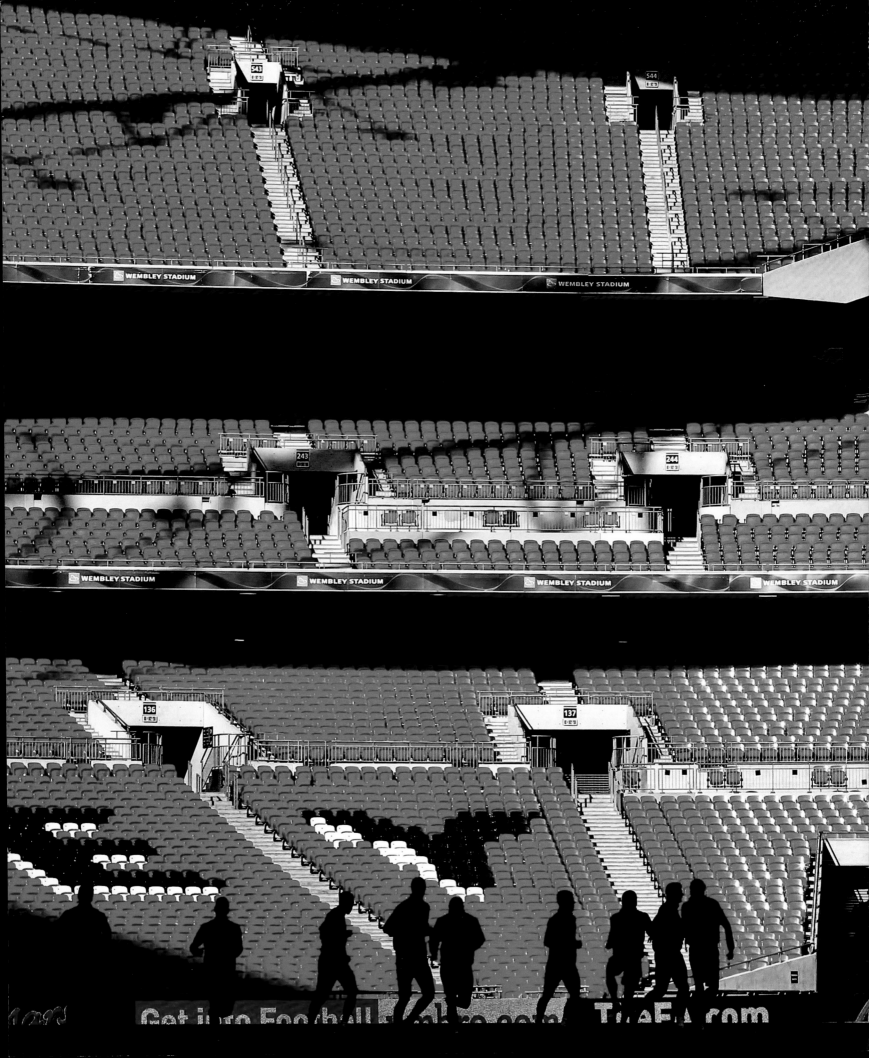

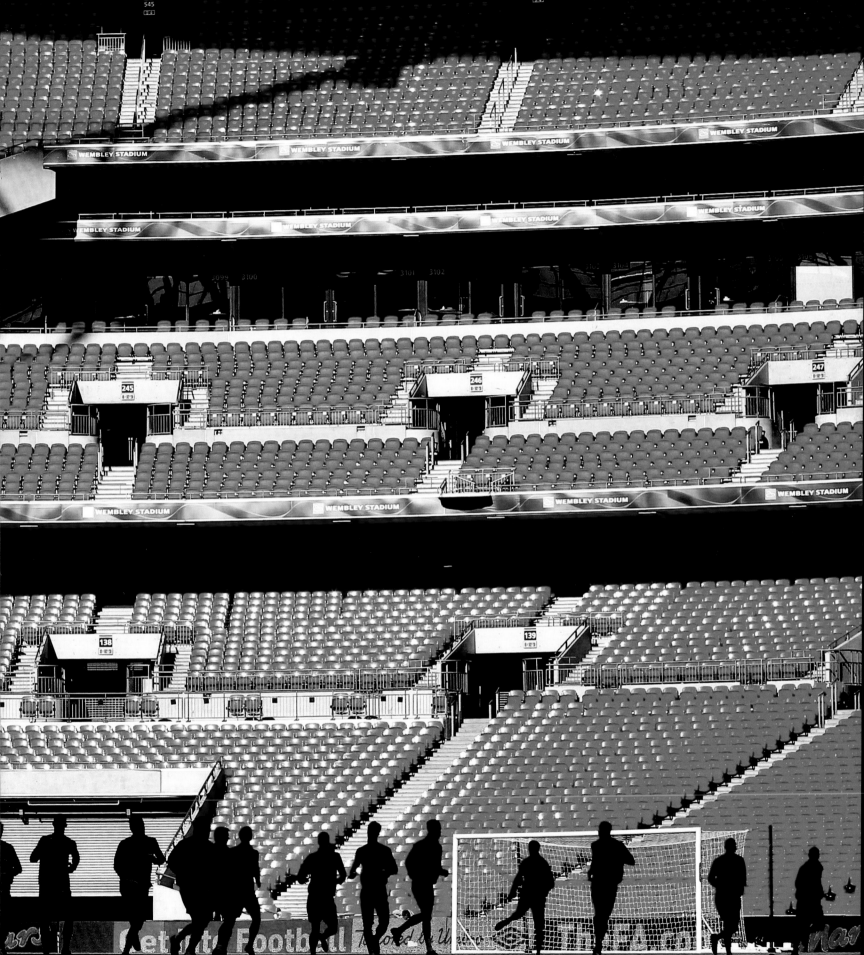

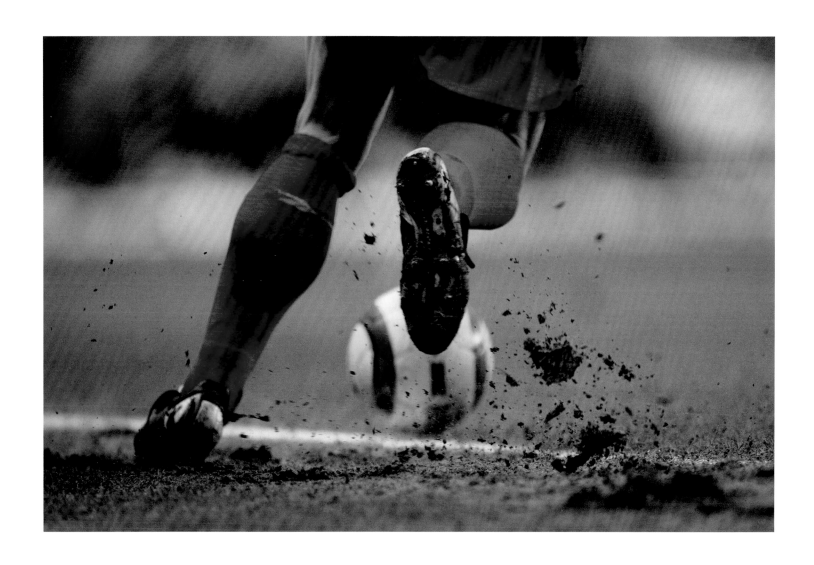

An attention to detail, Chelsea vs Liverpool, Stamford Bridge, London, 5th February 2006.

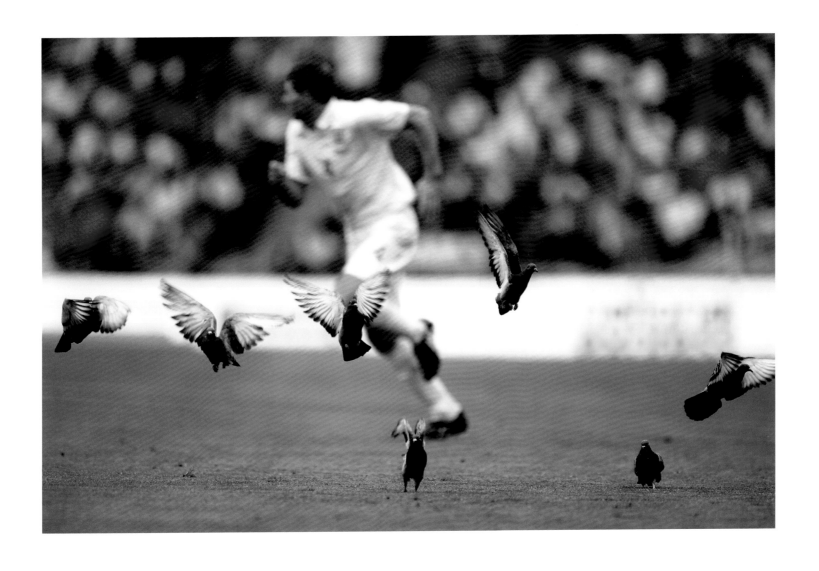

Steven Gerrard of England scatters the pigeons on the pitch against Slovakia at Wembley Stadium, 28th March 2009.

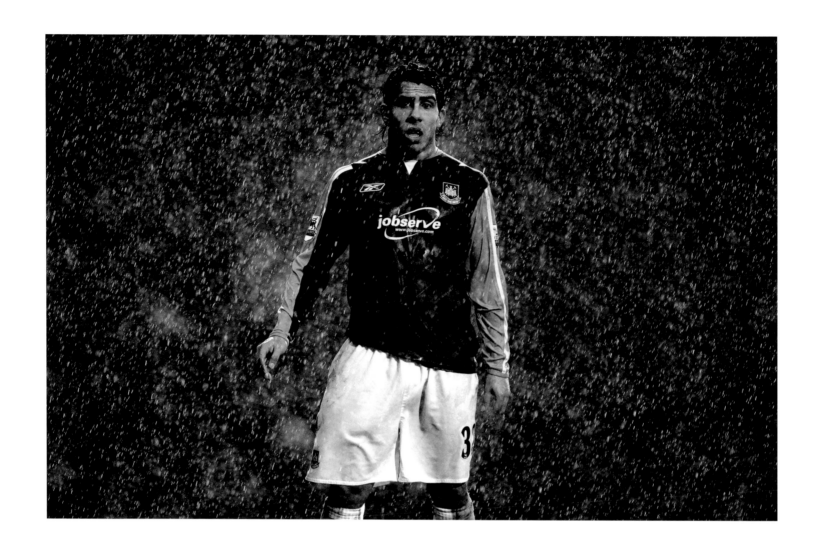

Carlos Tevez of West Ham United in the East London rain during the FA Cup Third Round against Brighton & Hove Albion at Upton Park, 6th January 2007.

Robert Green of West Ham United makes a fingertip save against Chelsea at Stamford Bridge, London, 13th March 2010.

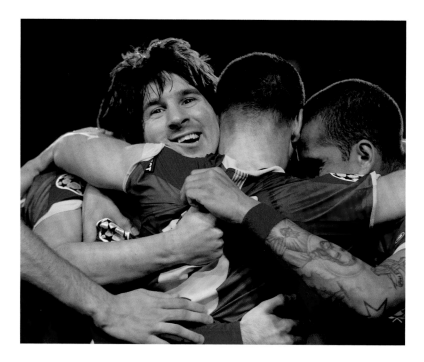

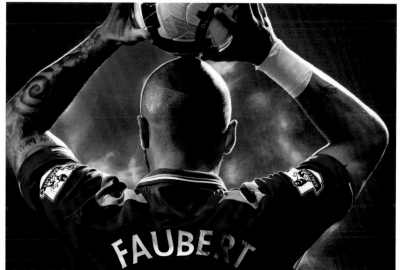

Top: Lionel Messi of FC Barcelona celebrates as his side defeat Arsenal 3-1 in the UEFA Champions League, Camp Nou, Barcelona, 8th March 2011.

Middle: Julien Faubert of West Ham United, Upton Park, London, 3rd November 2010.

Bottom: Cristiano Ronaldo celebrates scoring the winning goal for Real Madrid against Manchester City during their UEFA Champions League group stage match at the Estadio Santiago Bernabéu, Madrid, Spain, 18th September 2012.

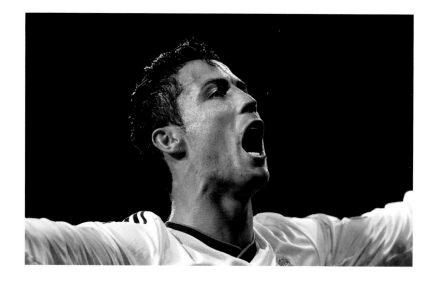

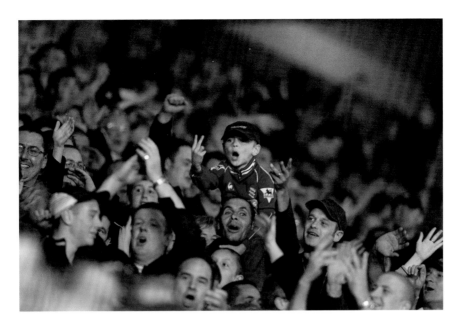

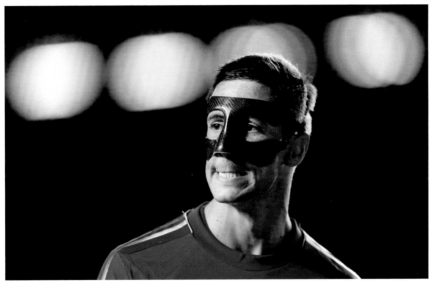

Top: A father and son cheer their side on as, Birmingham City lose to local rivals Aston Villa 1-2, in a second city derby in the Premier League at St Andrew's, Birmingham, 11th November 2007. The boy is possibly indicating that his team are about to score an equaliser.

Centre: Fernando Torres of Chelsea wearing a protective face mask after breaking his nose in an earlier match against Steua Bucharest faces FC Basel in the Champions League. The home side ran out 3-1 victors at Stamford Bridge, London, 2nd May 2013.

Bottom: David Beckham.

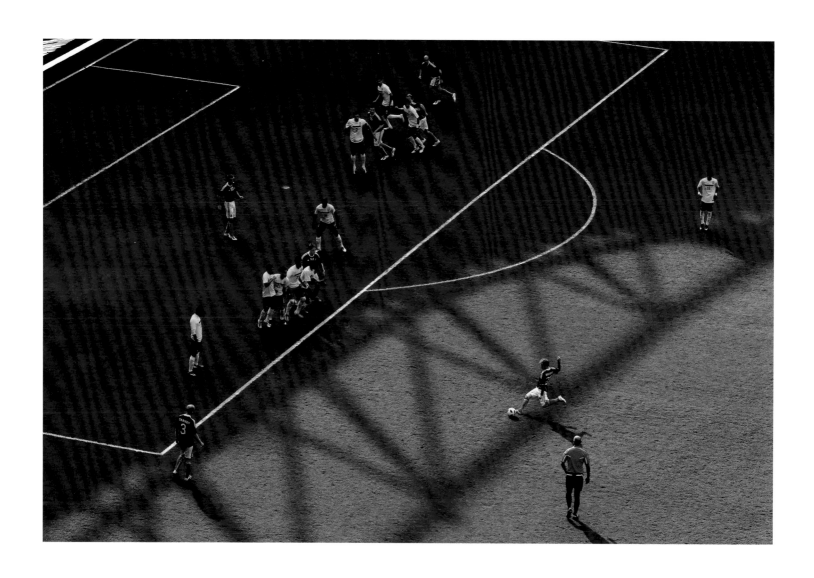

Substitute Barry Bannan takes a free-kick for Scotland vs Brazil in their 2-0 defeat at the Emirates Stadium, London, 27th March 2011.

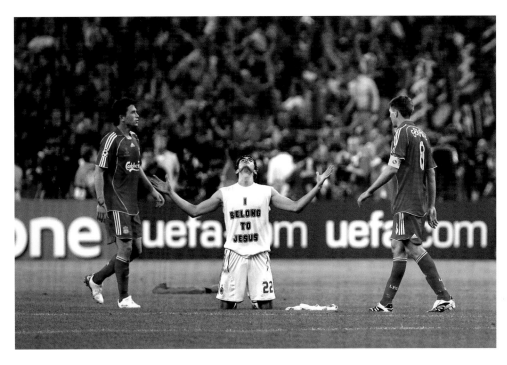

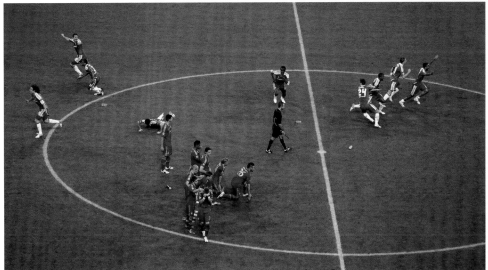

Top: Brazilian star Kaka, falls to his knees at the final whistle and unveils a vest which reads, 'I belong to Jesus', after AC Milan defeat Liverpool 2-1 in the Champions League Final at the Olympic Stadium, Athens, 23rd May 2007.

Bottom: Chelsea win the UEFA Champions League Final in a penalty shoot-out against Bayern Munich at the Allianz Arena, Munich, 19th May 2012.

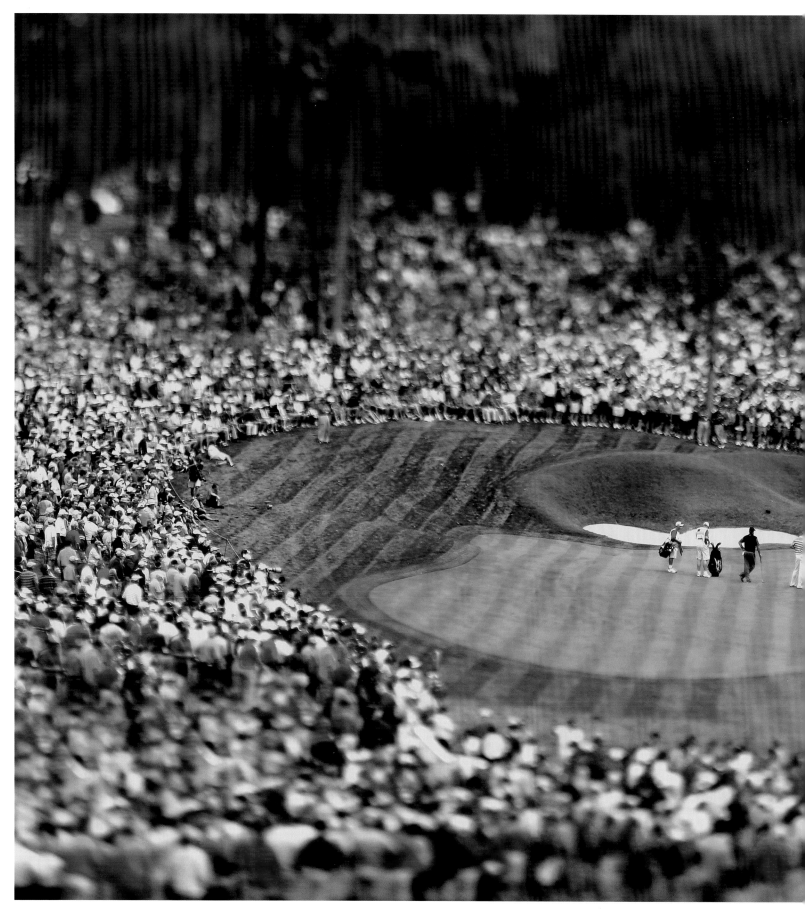

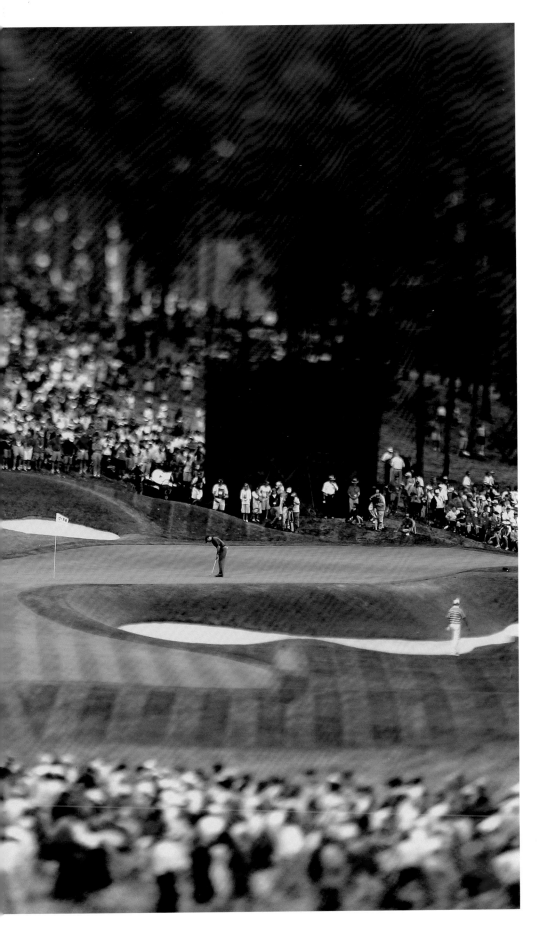

Views of the crowds on the course during Saturday's play in the first round of the Ryder Cup at Valhalla, Louisville, Kentucky, USA, 20th September 2008.

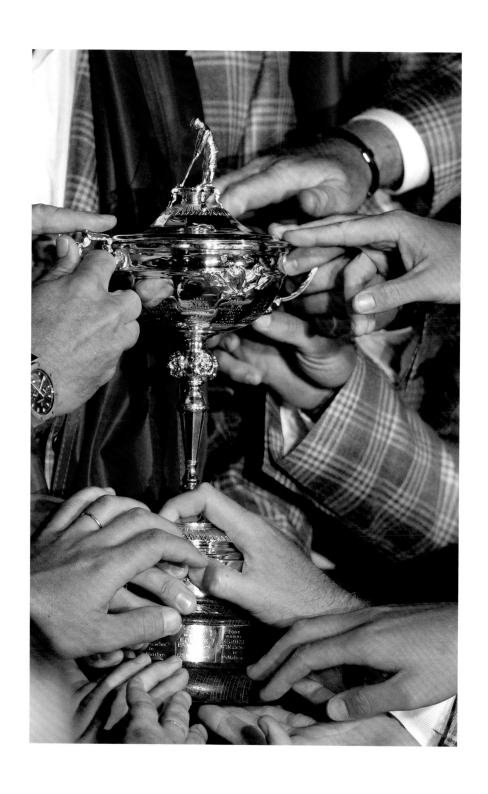

The 39th Ryder Cup won by Team Europe at the Medinah Country Club in Illinois,
USA, 30th September 2012.

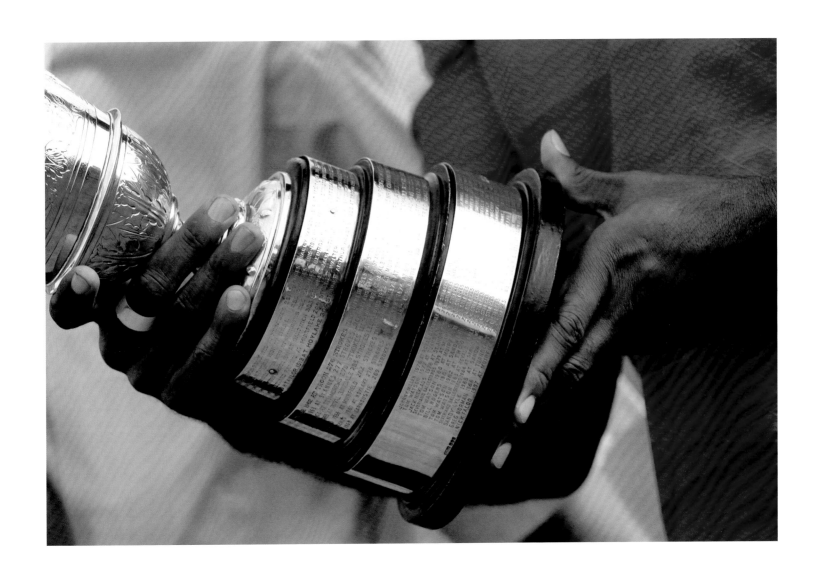

Tiger Woods with the Open Championship trophy at the Royal Liverpool Golf Club, Hoylake, Merseyside, 7th July 2006.

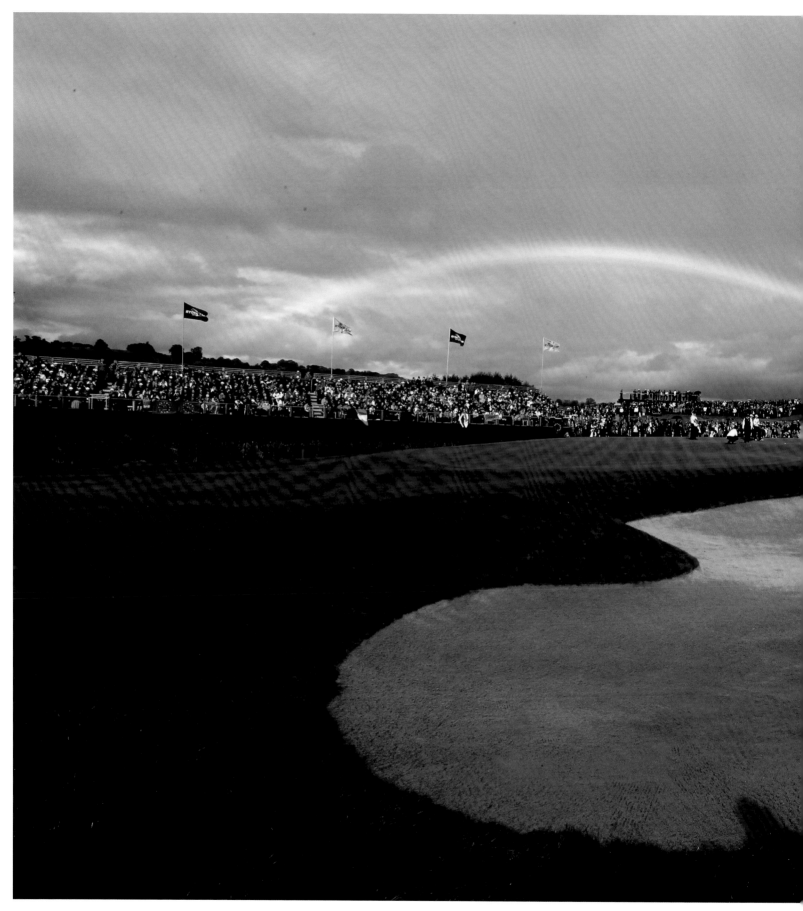

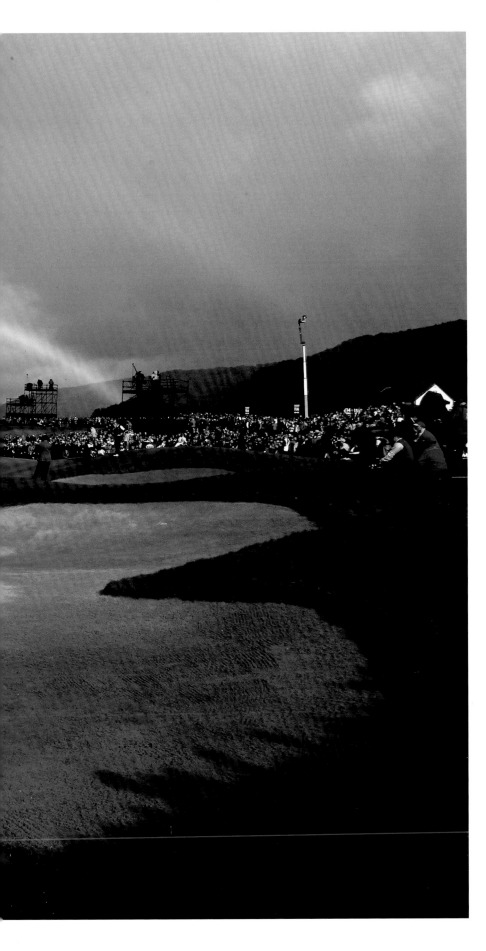

A rainbow lights up the fourteenth green and the grandstands as McIlroy and McDowell defeat Johnson and Mahan (3 & 1) during the 38th Ryder Cup at Celtic Manor, Newport, Wales, 3rd October 2010.

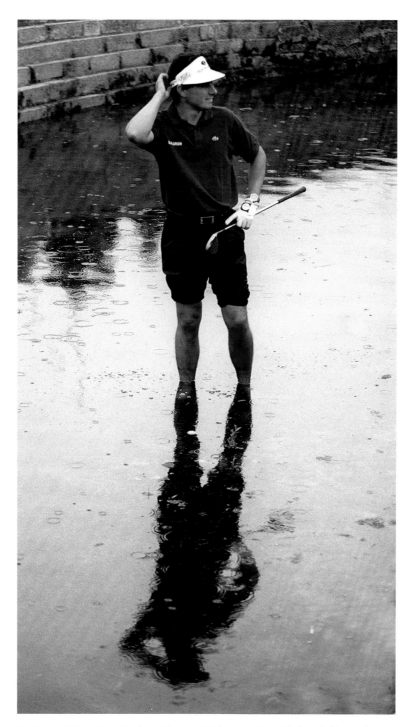

On the eighteenth hole, Jean Van de Velde scratches his head, his sunken ball visible in his shadow, standing in the Barry Burn, ruminating on the seemingly unassailable lead he has spectacularly thrown away during the final round of The Open Championship at Carnoustie, Scotland, 18th July 1999.

Tiger Woods tees off from the first on the final day of the 2012 Ryder Cup at Medinah Country Club, Illinois, USA, 30th September 2012.

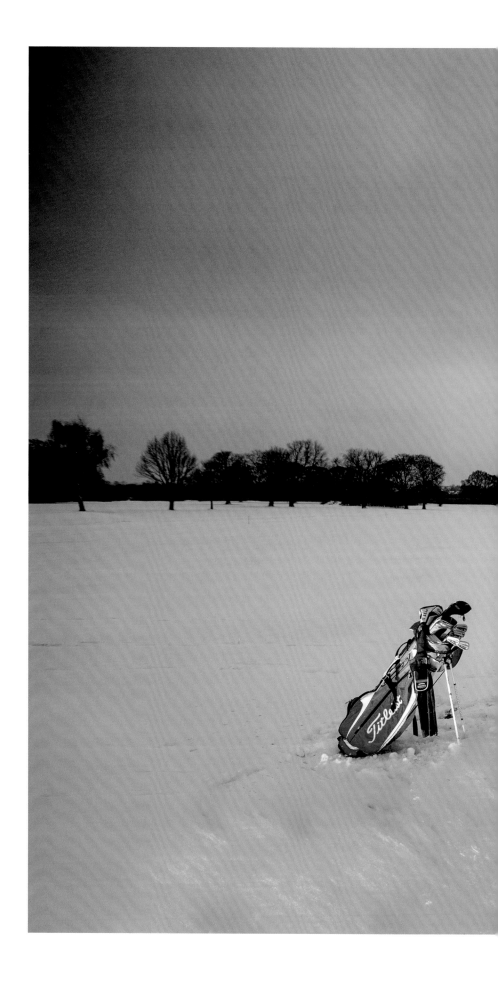

Connor O'Brien does not let six inches of snow deter his routine as he cuts out an oasis of green on the practice range at Mid Herts Golf Club, Wheathampstead, 21st January 2012.

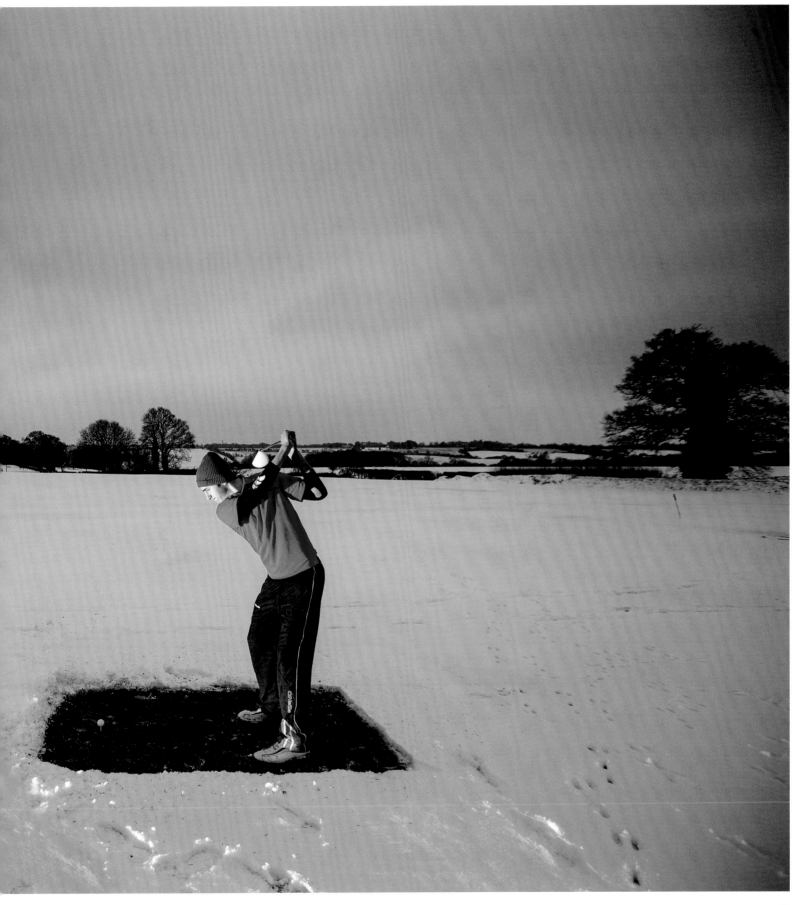

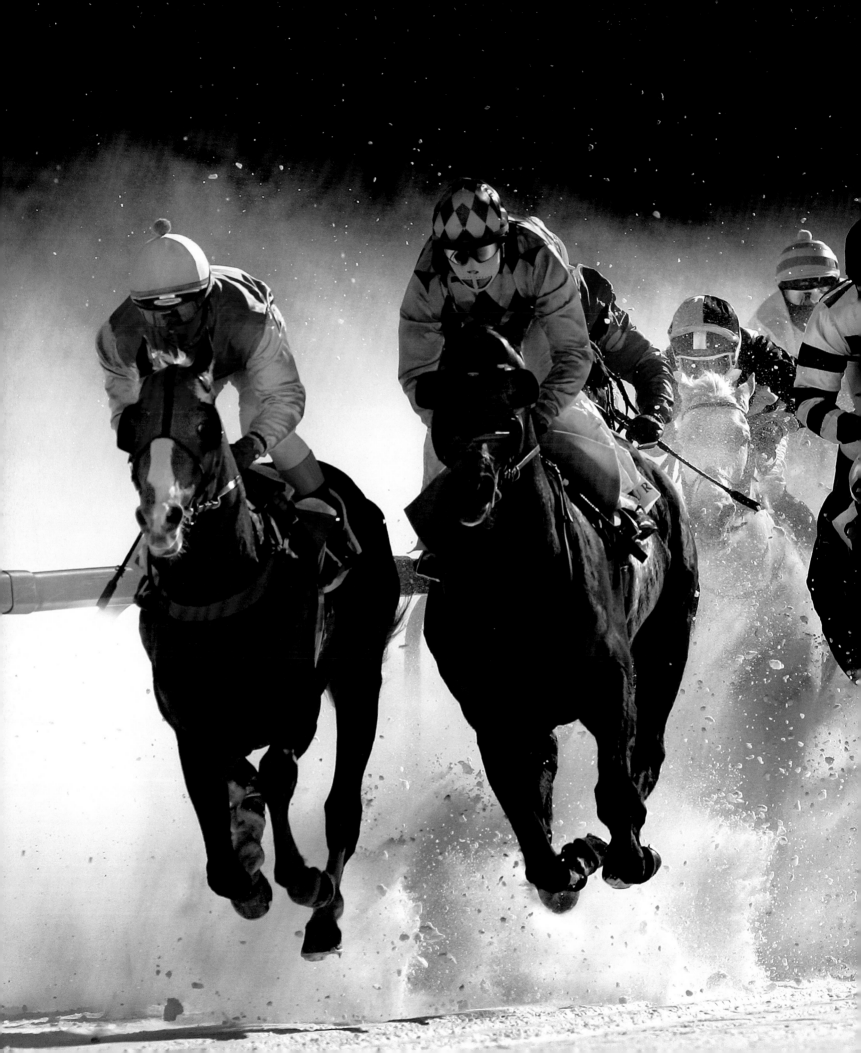

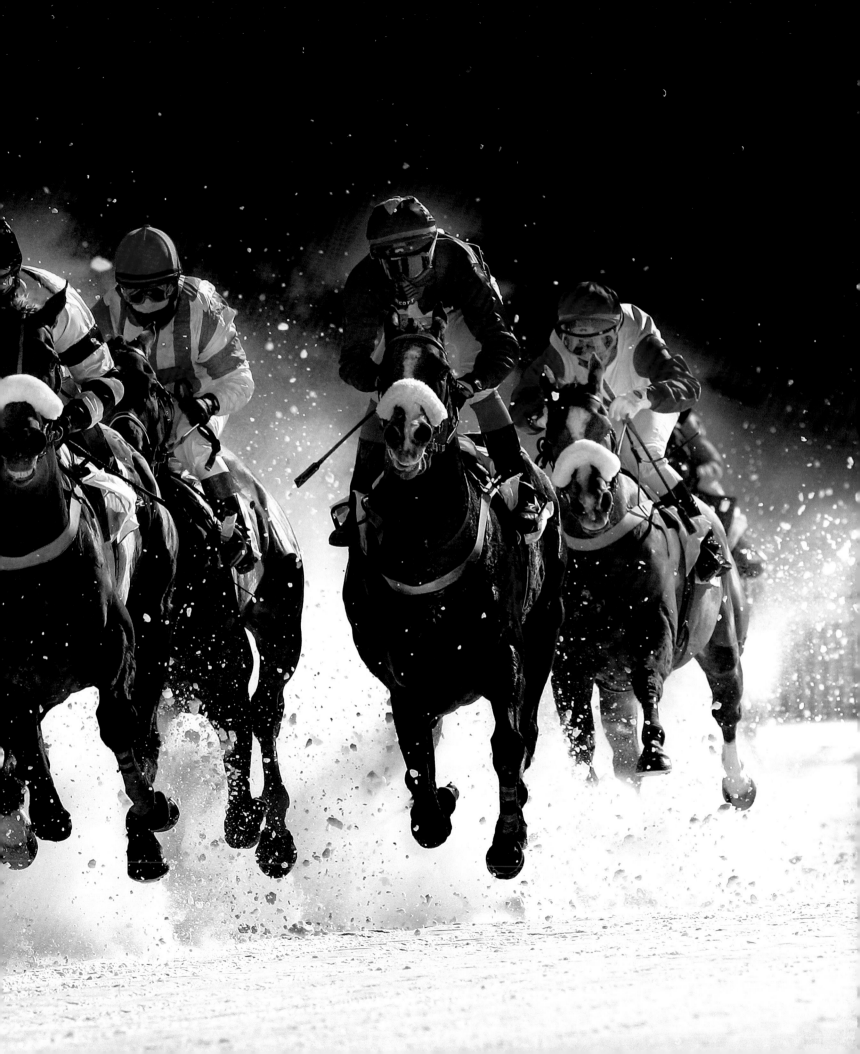

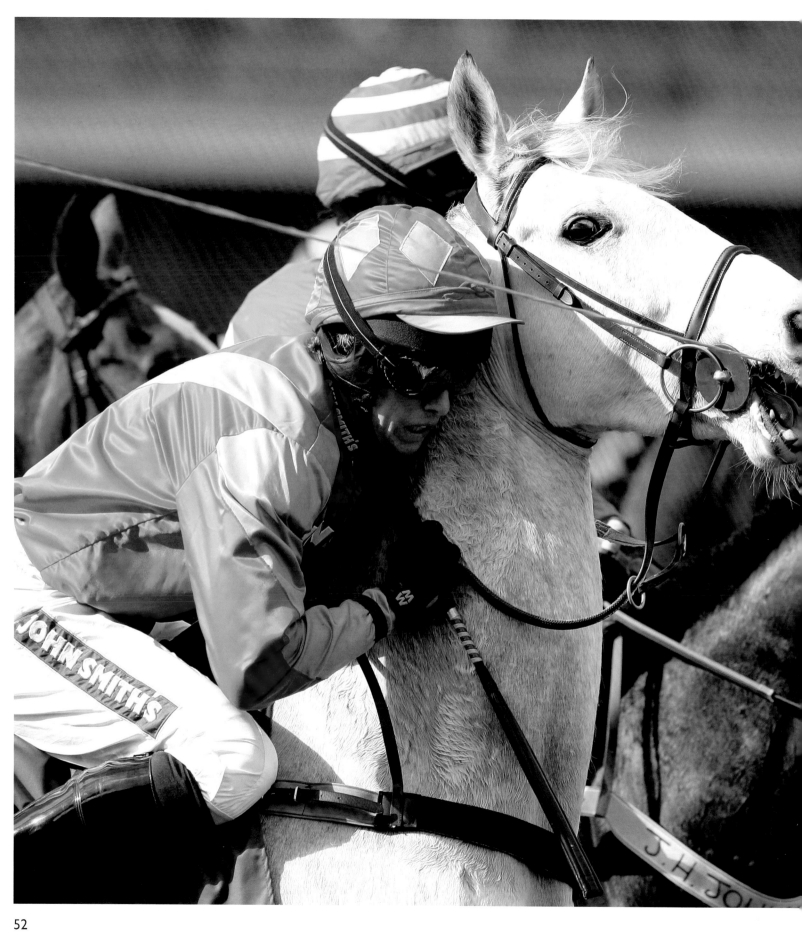

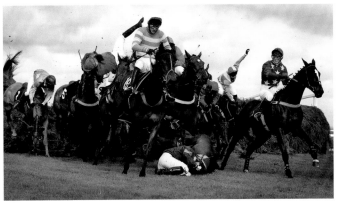

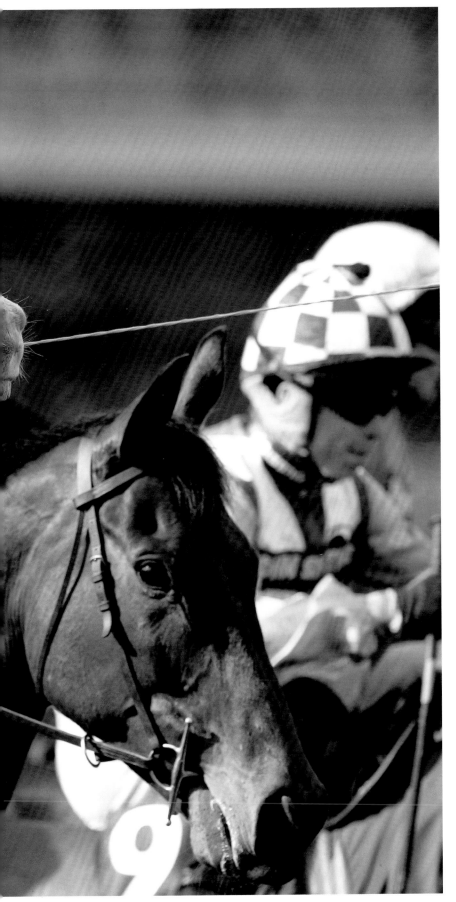

Previous page: The 101st running of White Turf - the European Snow Meeting on the frozen lake at St. Moritz, Switzerland, 2nd March 2008.

Opposite: The start of the Grand National at Aintree, Liverpool in 2006 sees horse Ross Comm ridden by Dominic Elsworth caught in the starting tape. Several measures were subsequently introduced to improve horse safety, 8th April 2006.

Top: Runners and riders at the infamous Chair during the Grand National, 3rd April 2003.

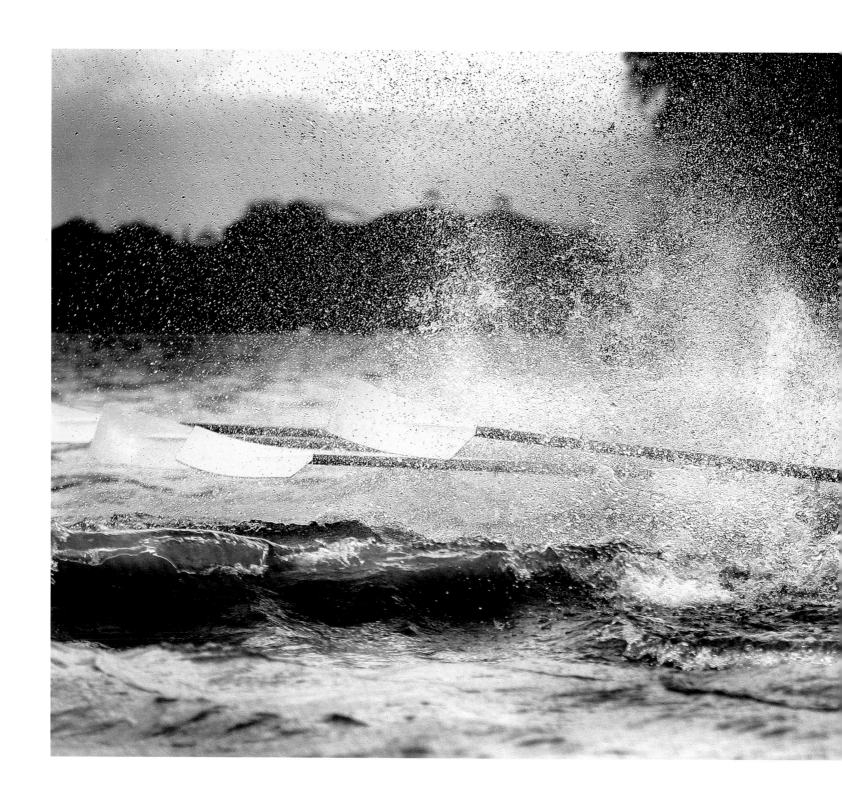

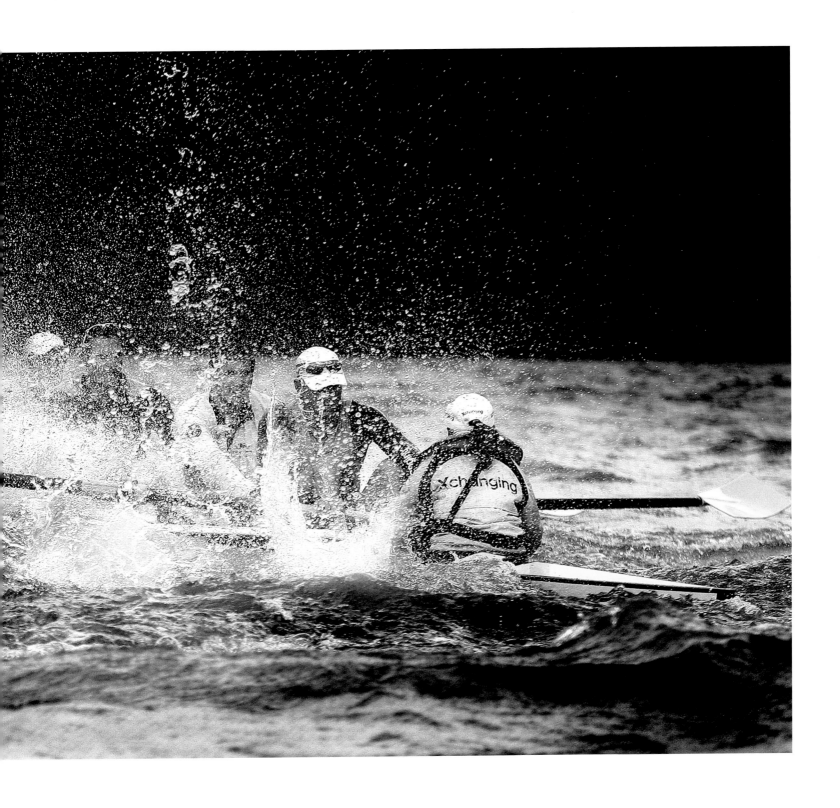

Cambridge University, in training for the 155th running of the Boat Race, find the going between Putney and Mortlake tough, London, 25th March 2009.

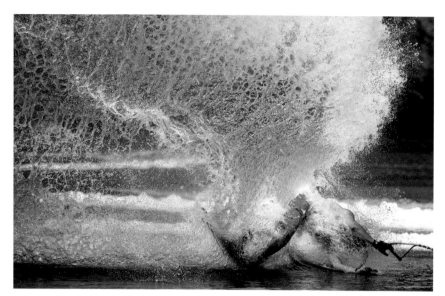

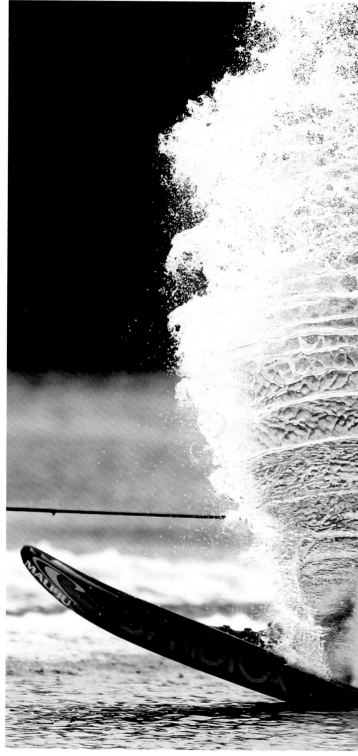

Top: British Water Ski champion Freddie Winter takes an enormous crash during a high speed run at Thorpe Lake as he trains for the World Championships in Chile. Shot at 1/8000th of a second shutter speed, Chertsey, Surrey, 6th April 2013.

Opposite: William Asher competes in the Open Men's Slalom in the 2010 European Water Ski Championships at Thorpe Park near London, 10th August 2010.

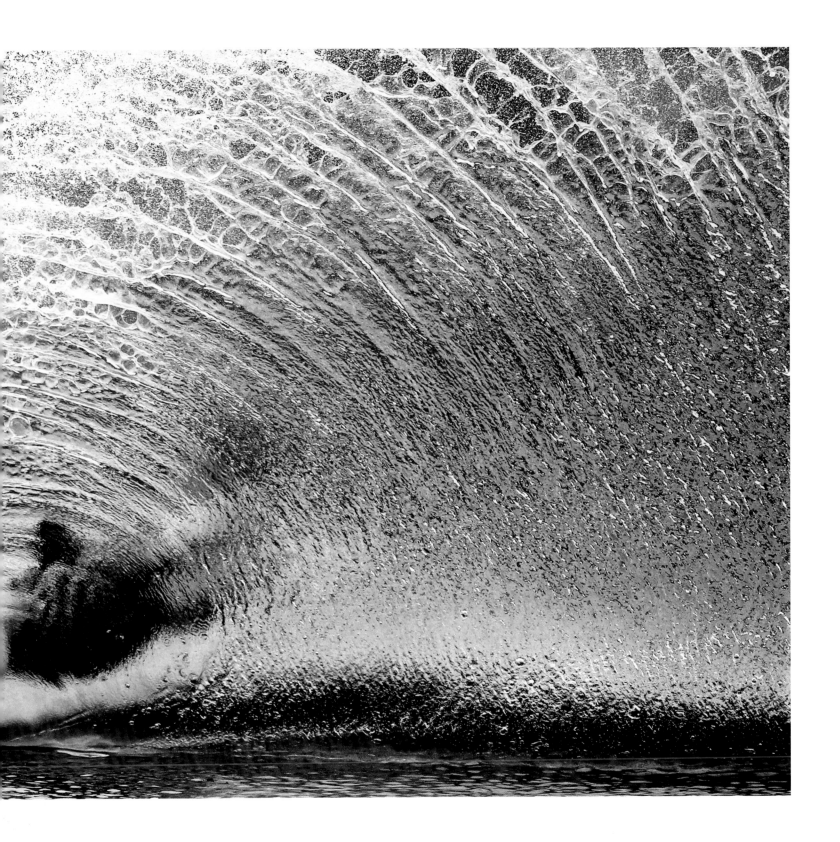

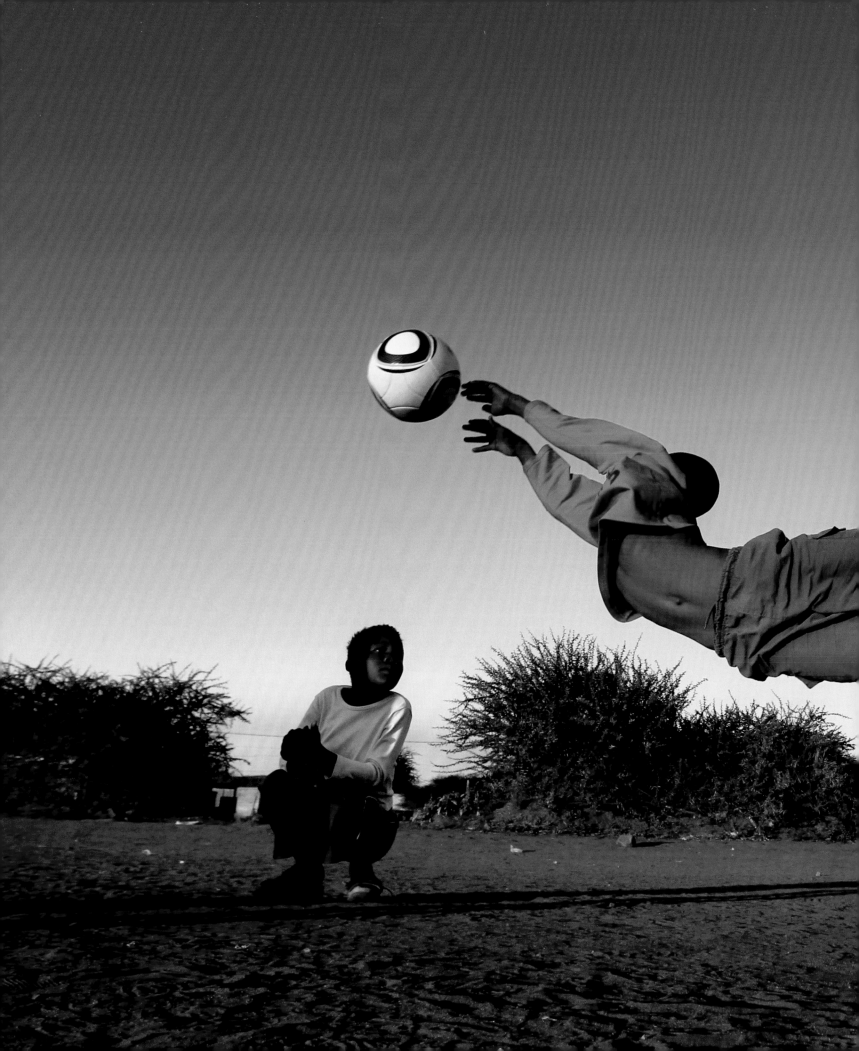

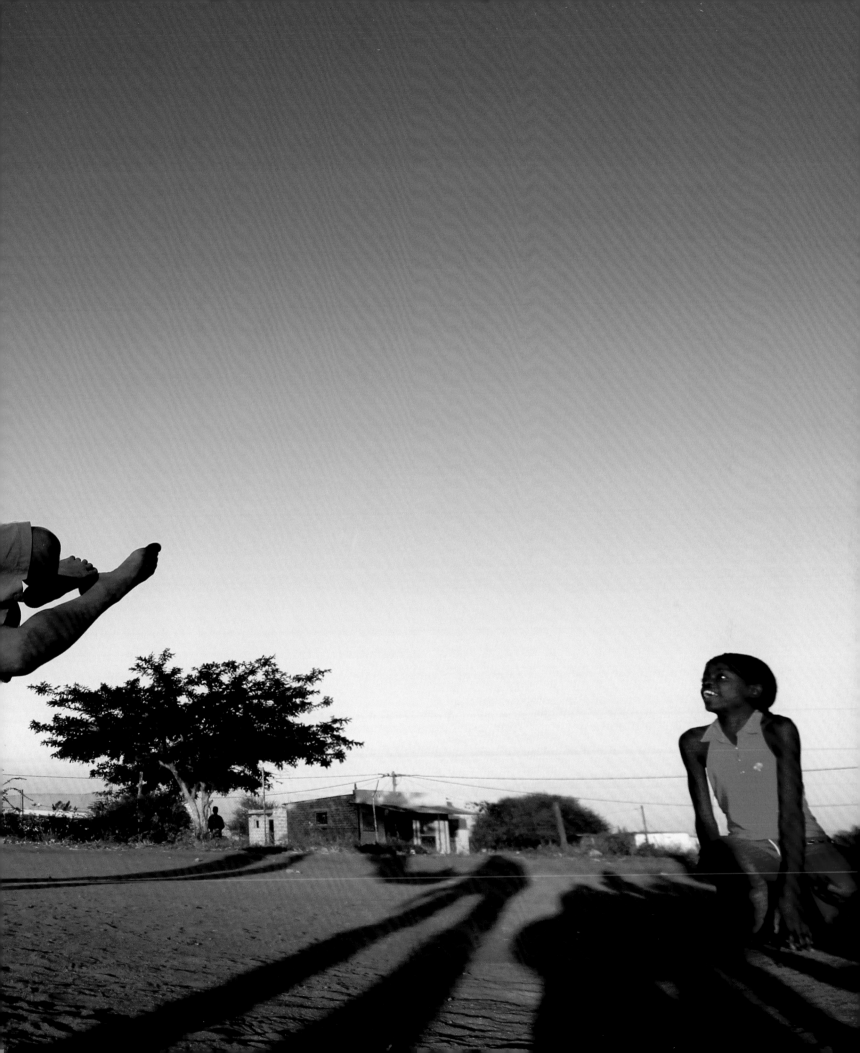

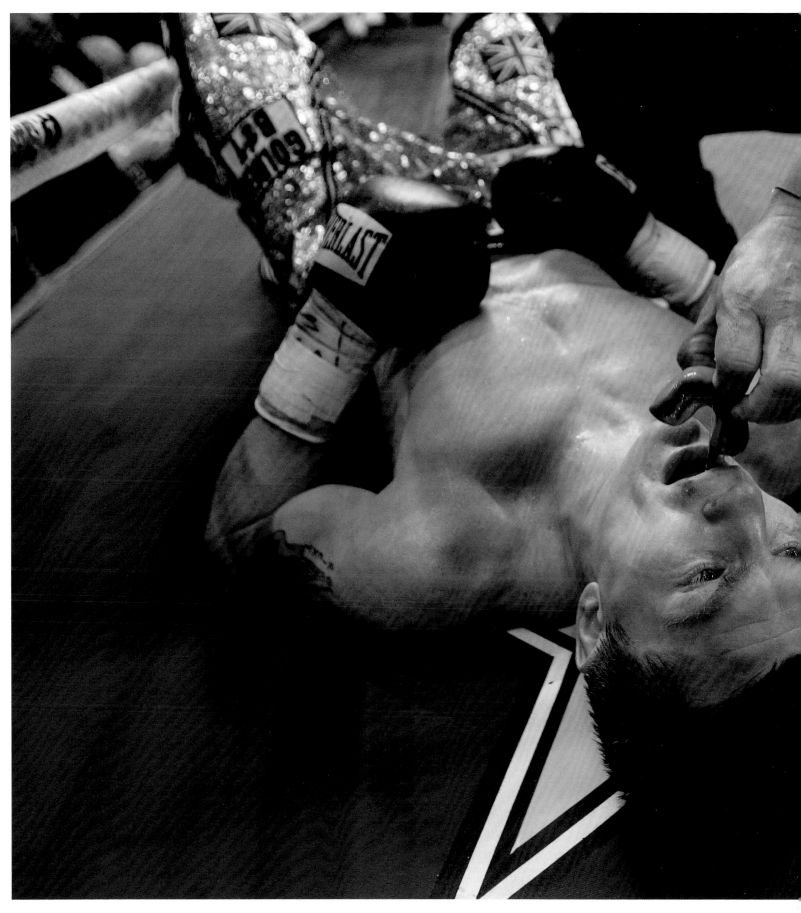

Previous page: Katlego Dihoko of Kagiso township, near Rustenburg, plays goalkeeper while his brother and sister act as goalposts, South Africa, 20th June 2010.

Opposite: Referee Joe Cortez quickly removes the gumshield of British welterweight Ricky Hatton after he is knocked out in the tenth round by American Floyd Mayweather Jr. at the MGM Grand Hotel Arena, Las Vegas, Nevada, USA, 8th December 2007.

Next page: Fernando Alonso in the McLaren swings round the first corner chicane as his teammate Lewis Hamilton takes a shortcut at the Italian Grand Prix, Monza, 9th August 2007.

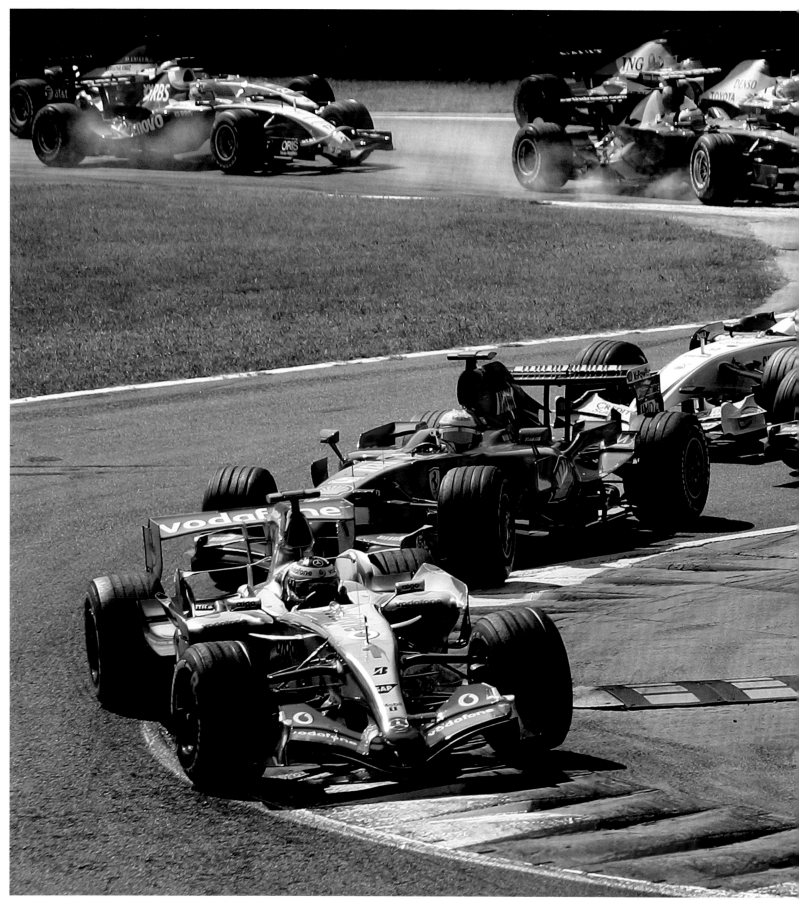

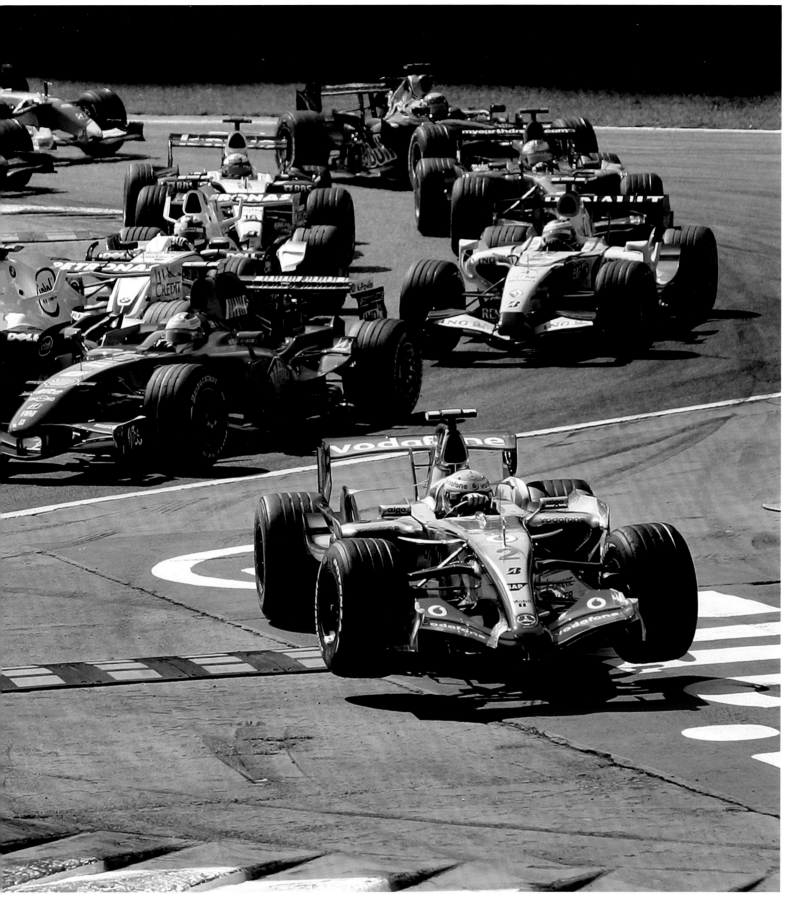

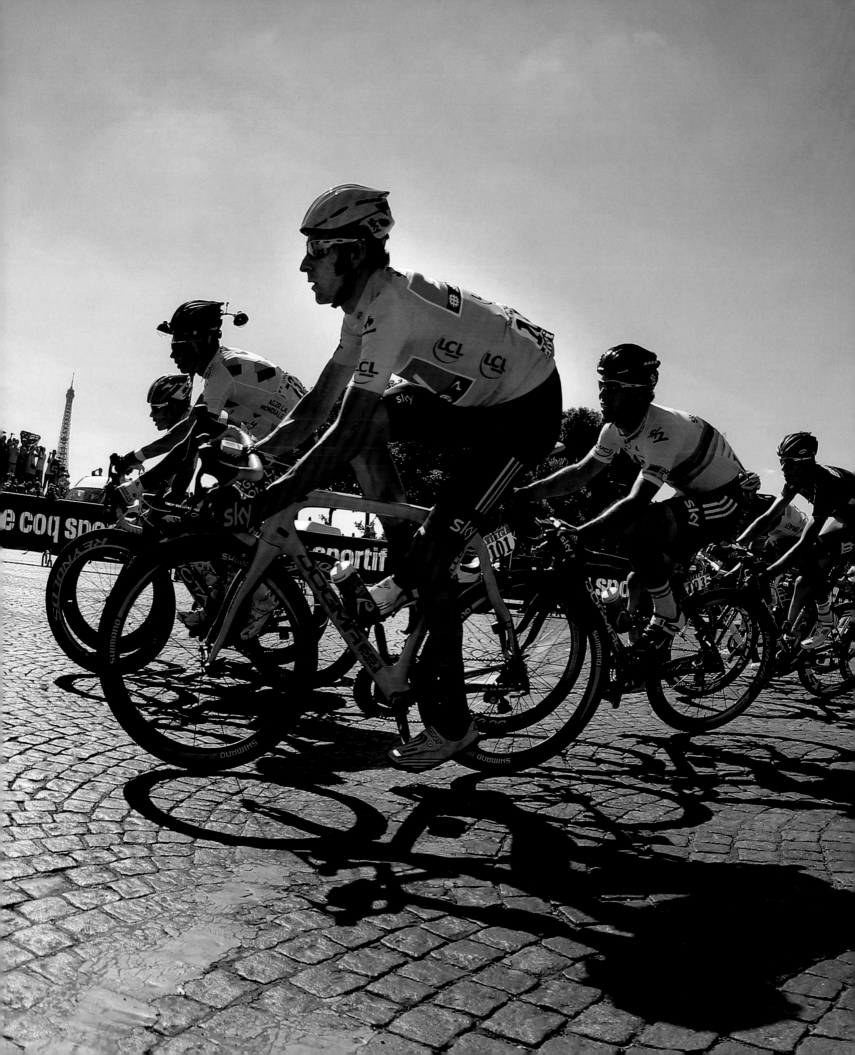

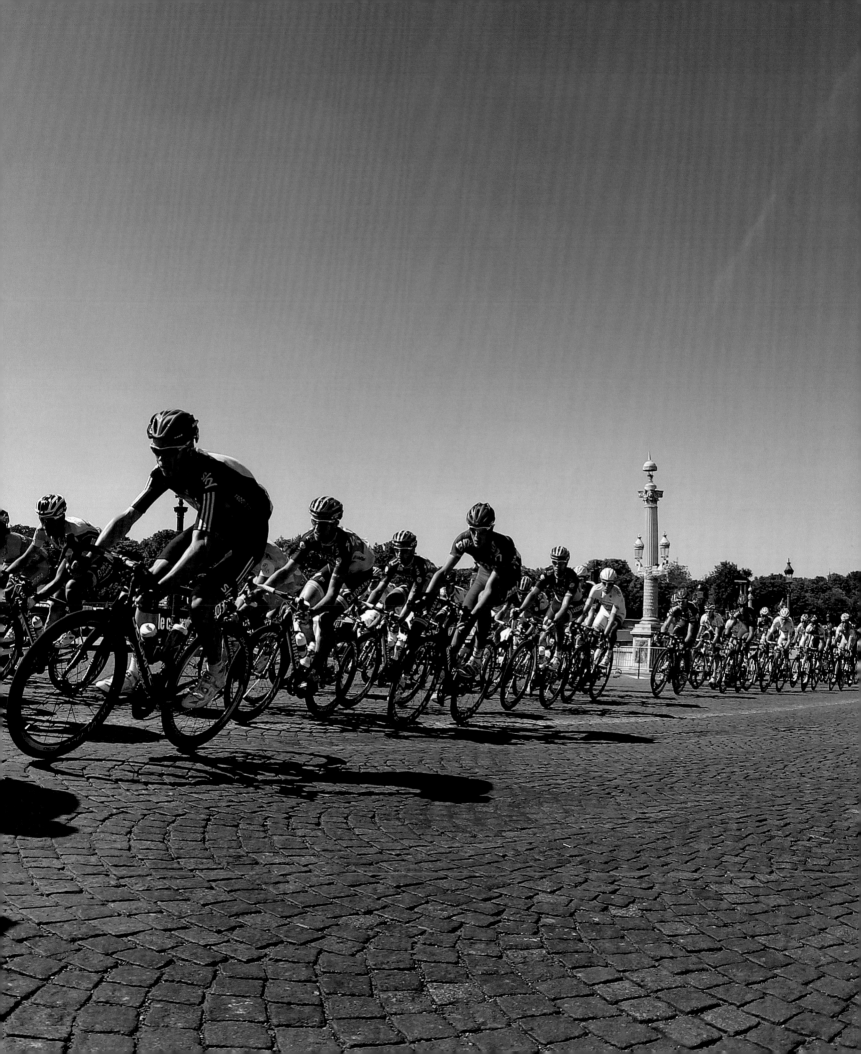

Previous page: With the Eiffel Tower just visible in the background, British cyclist Bradley Wiggins, in the yellow jersey, makes his triumphant entrance on to the famous cobbles of the Champs-Élysées, Paris in the final stage of the Tour de France, 22nd July 2012.

Opposite: An extreme downhill mountain bike rider attacks a black run in the woods high above the ski resort of Les Arcs, which stands at an elevation of 3,250m above sea level, France, 2nd September 2009.

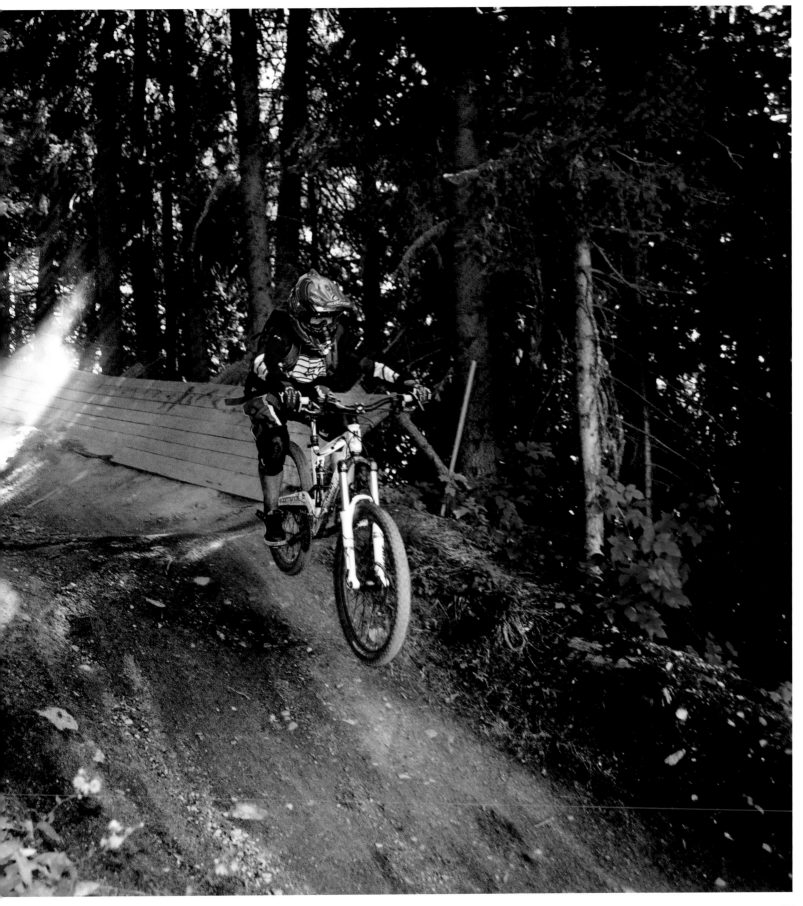

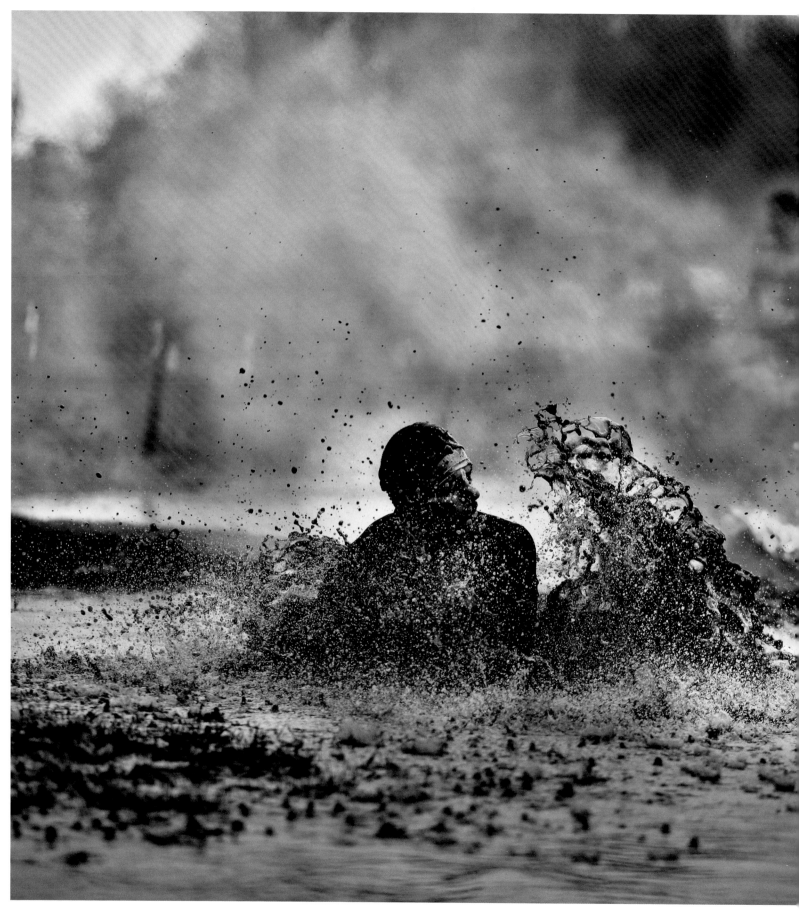

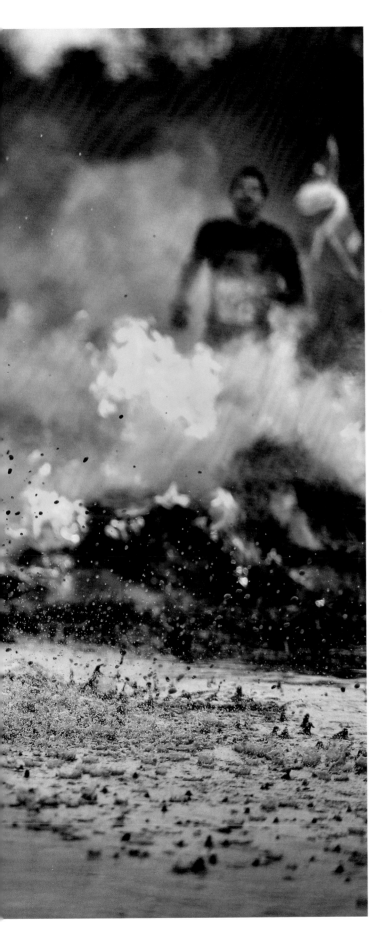

Opposite: Competitors in the notorious Tough Guy Challenge push themselves to the very limits of fitness during a 15km endurance race around a gruelling Black Country course, Perton, Staffordshire, 26th January 2014.

Next page: Sabre fencers at the 2008 Summer Olympic Games, Beijing, China, 13th August 2008.

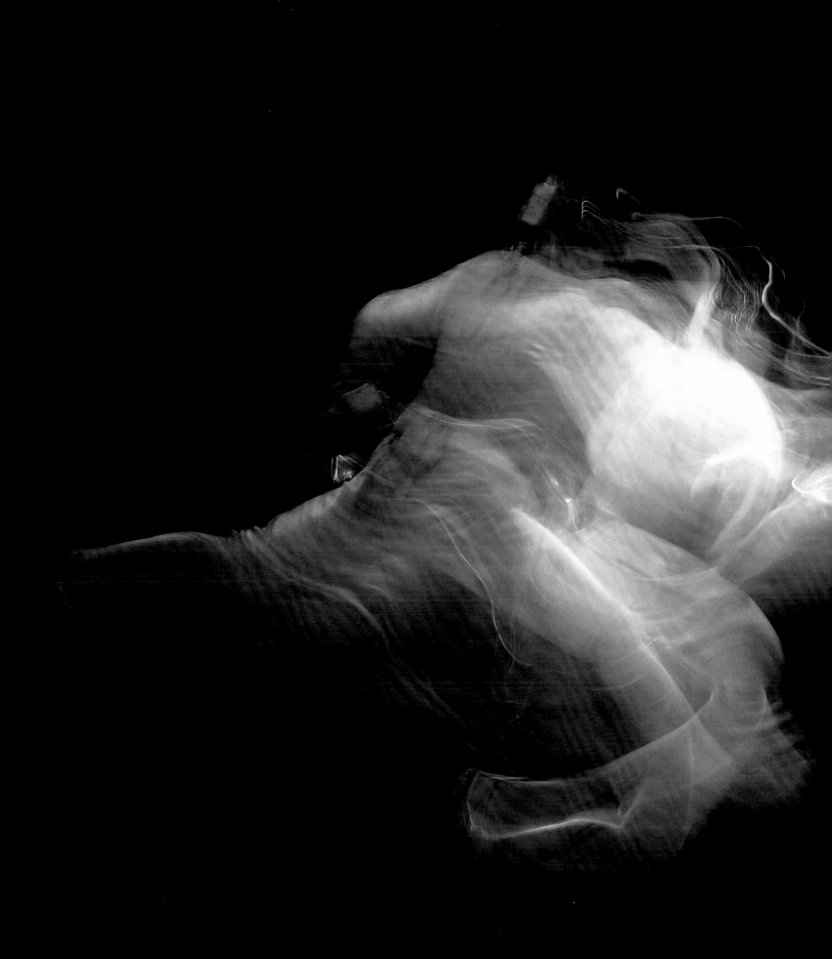

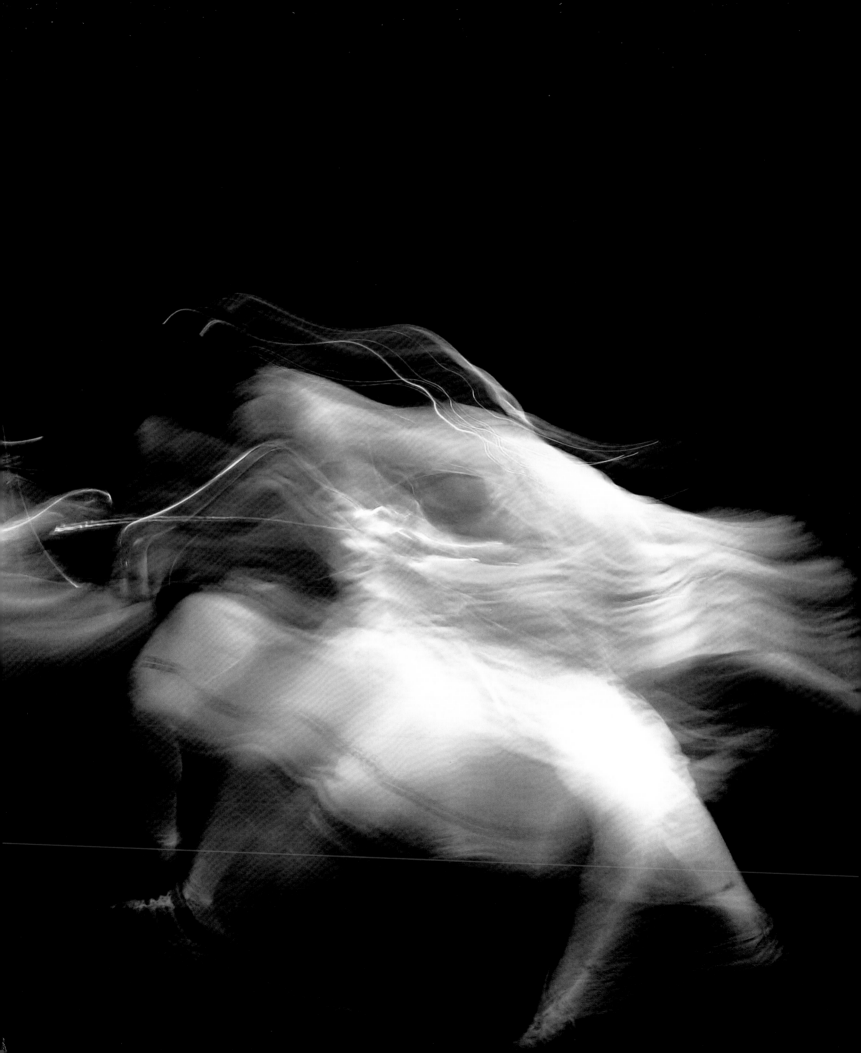

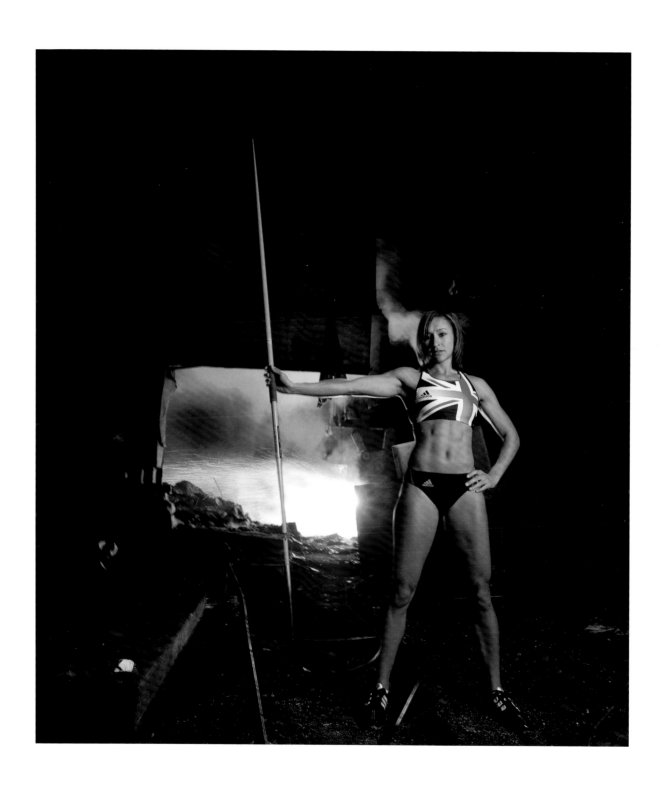

Jessica Ennis, member of the City of Sheffield Athletics' Club, strikes a pose at a steel foundry in her home city, 26th November 2009.

Cathy Freeman at the start of the Women's
400m Final at the 2000 Summer Olympics
about to win gold for Australia in Sydney, 25th
September 2009.

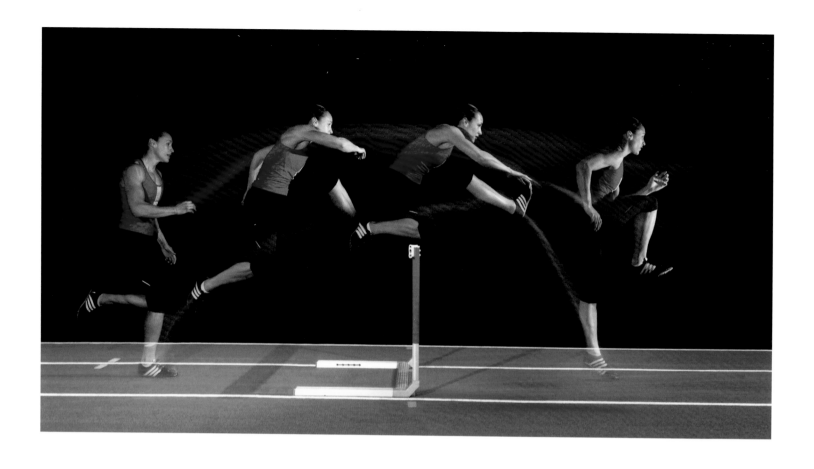

Above: The Times exclusive pictures of Team GB heptathlete Jessica Ennis at the Institute of Sport in Sheffield, where her coach Toni Minichiello explained to me the technical details shown in this strobe-effect picture of her working at full pace over the hurdles, 23rd April 2010

Opposite: Several competitors show the determination required during the Women's Pole Vault competition at the Olympic Stadium, 2012 Summer Olympics, London 6th August 2012.

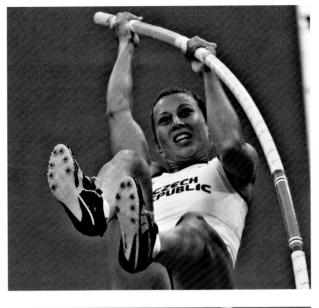 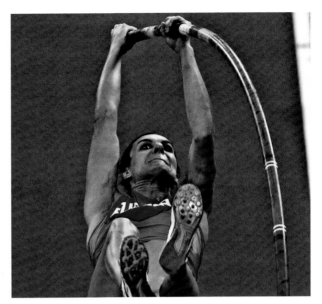

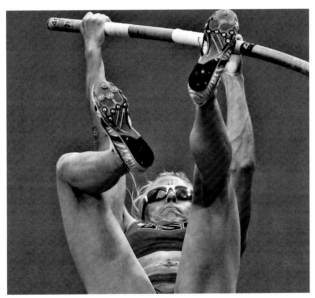 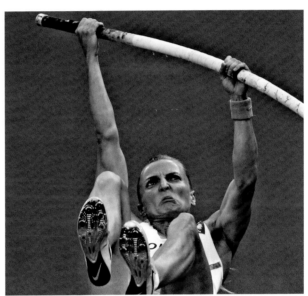

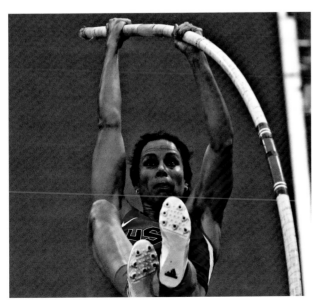 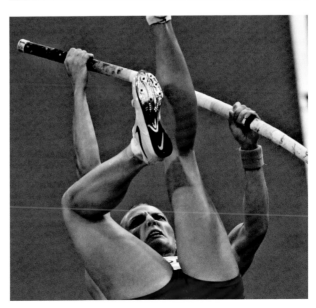

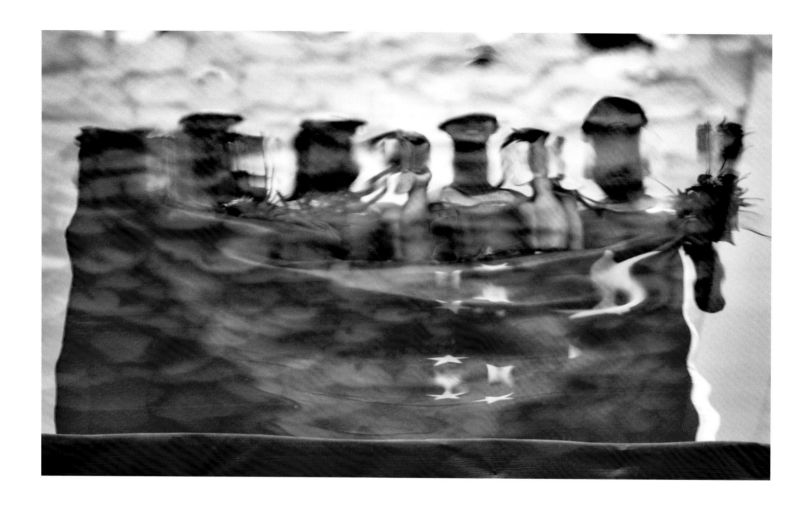

The Chinese Women's Coxless Four are captured with their gold medals and national flag shimmering in the reflection of the water during the medal ceremony at the Summer Olympics, Beijing, 17th August 2008.

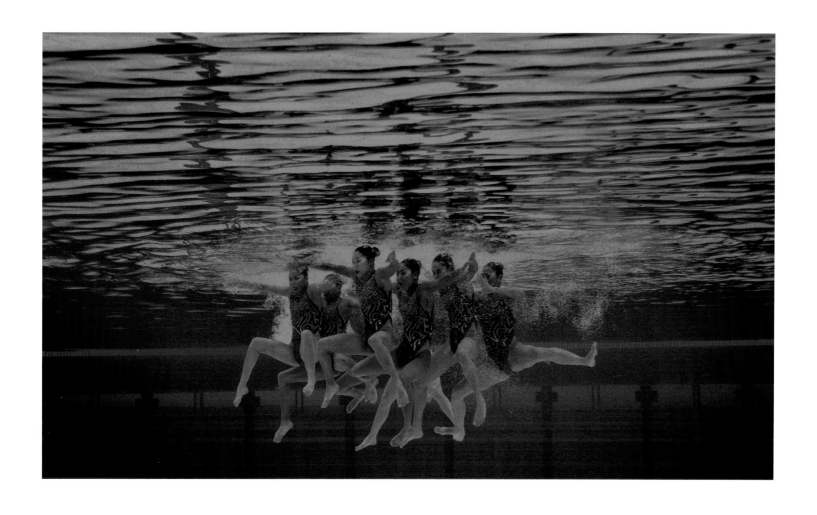

Team Japan during the Women's Synchronised Swimming final at the Aquatics Centre, 2012 Summer Olympics, London, 10th August 2012.

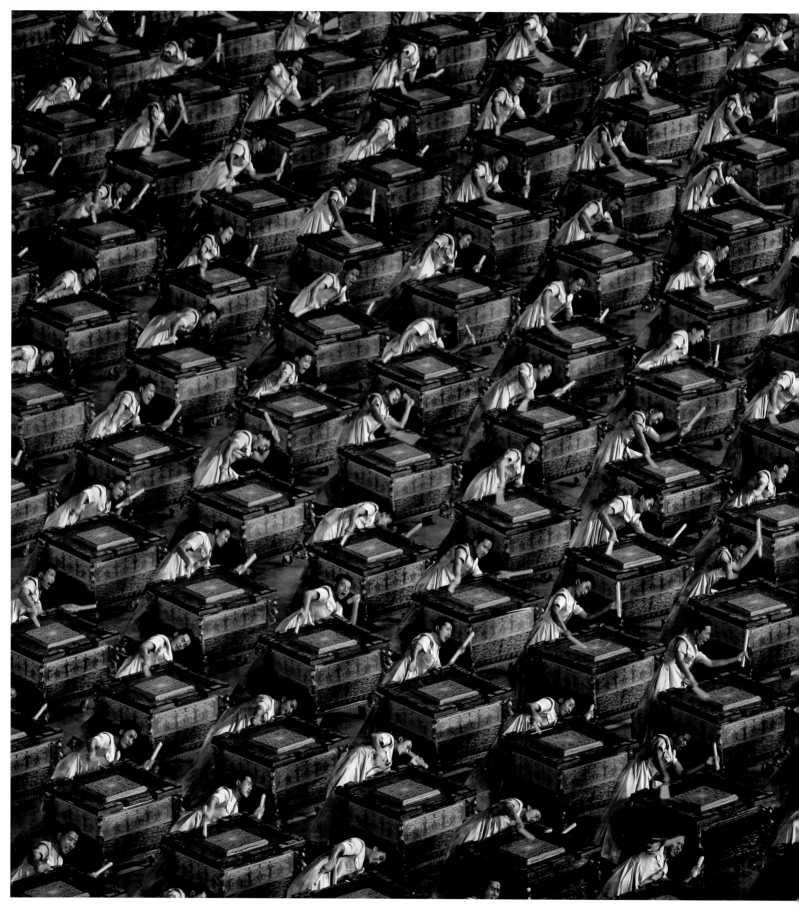

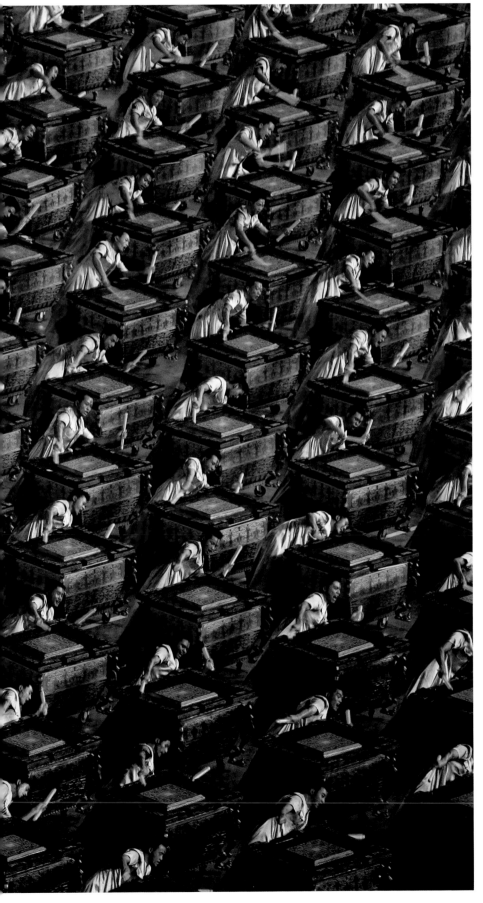

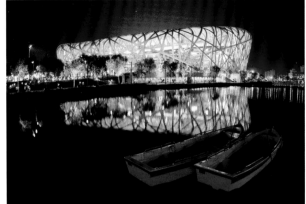

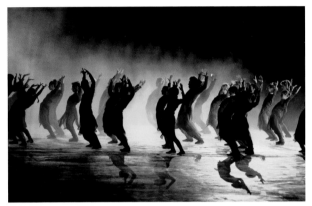

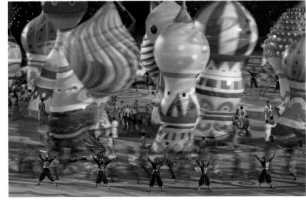

Left: Thousands of drummers perform during the Opening Ceremony of the 2008 Beijing Summer Olympics at the National Stadium, 8th August 2008.

Top: The Beijing National Stadium or Bird's Nest, Beijing Olympics, 2008.

Middle: Dancers during the Opening Ceremony, Summer Olympics, London, 2012.

Bottom: Opening Ceremony of the Winter Olympics, Sochi, Russia, 2014.

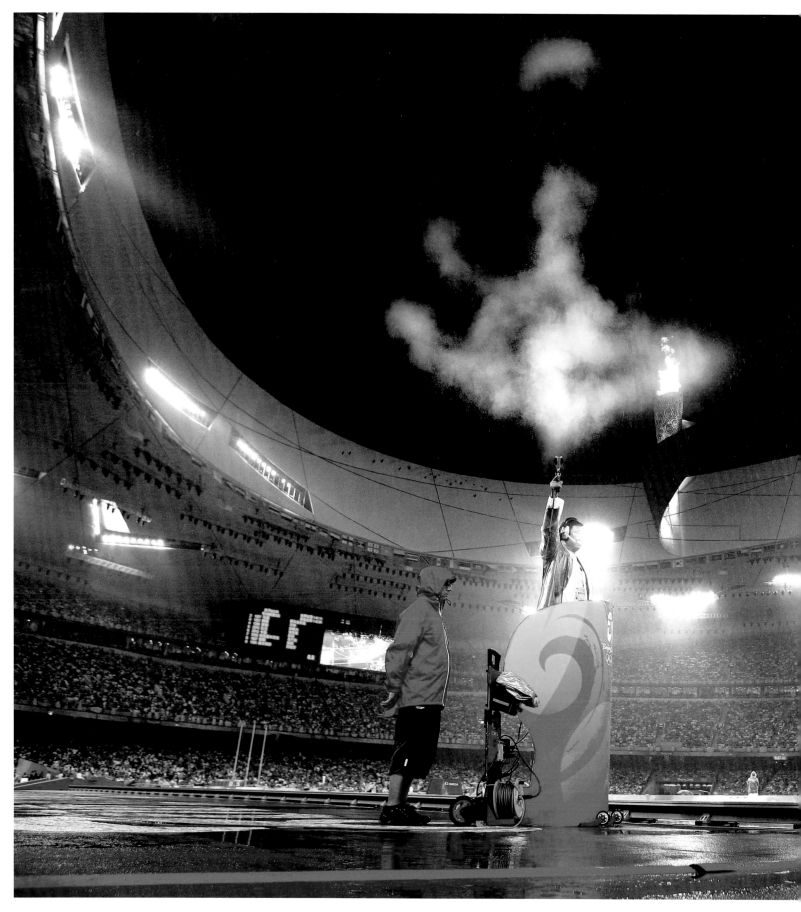

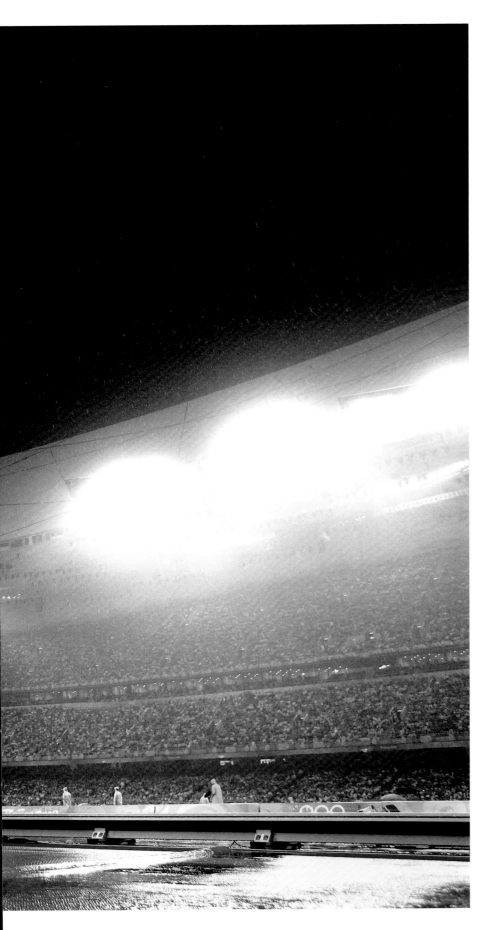

Starter fires his pistol on a rainy night during the track and field event at the Beijing Olympics, 14th August 2008.

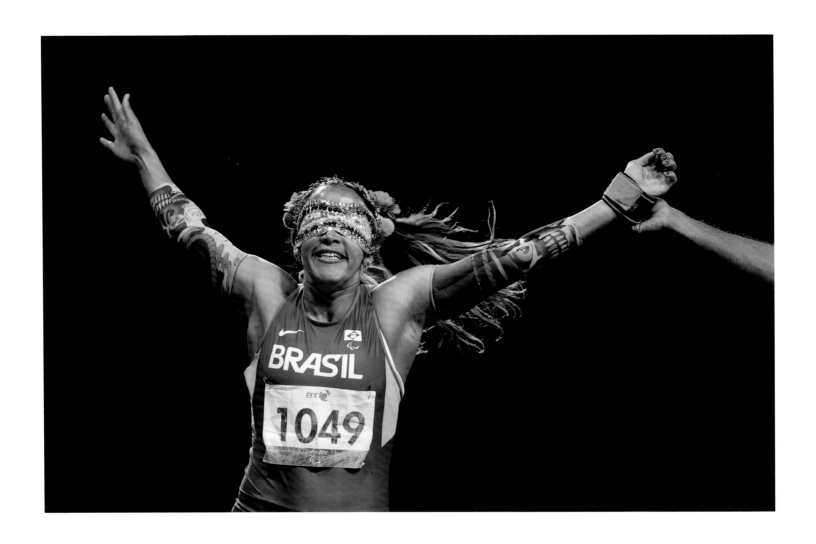

Blind sprinter Zerezinha Guilhermina with her brother and guide Guilherme Soares de Santana celebrate gold for Brazil in the Women's 100m T11 final at the Paralympics, Olympic Stadium, London, 9th September 2012.

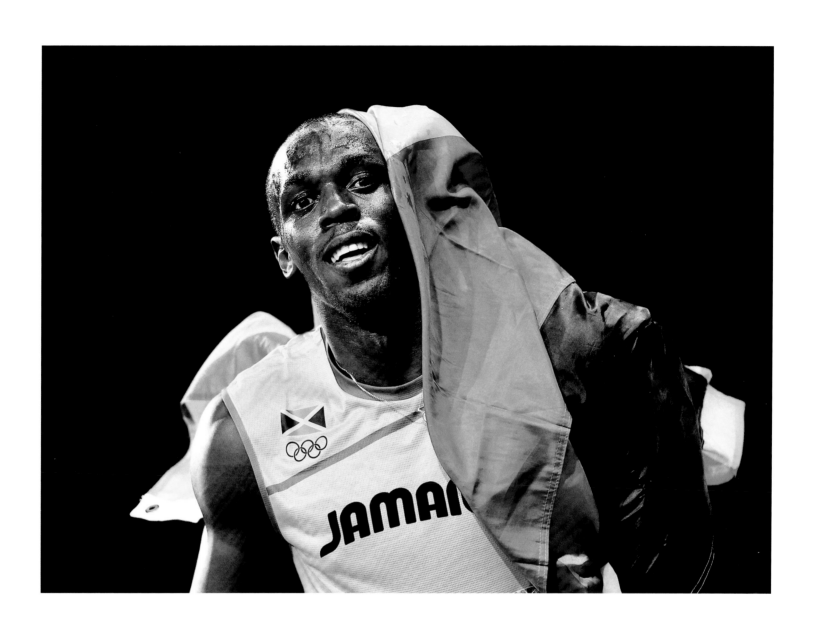

Usain Bolt wins the Men's 100m for Jamaica at the London 2012 Olympics, Olympic Stadium, 27th July 2012.

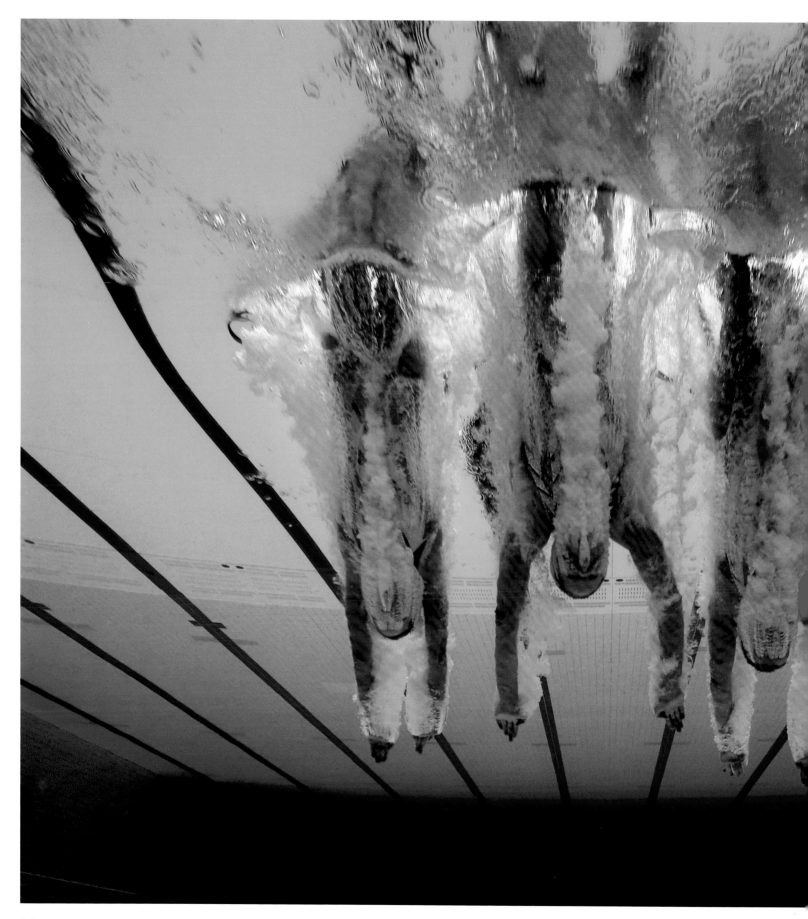

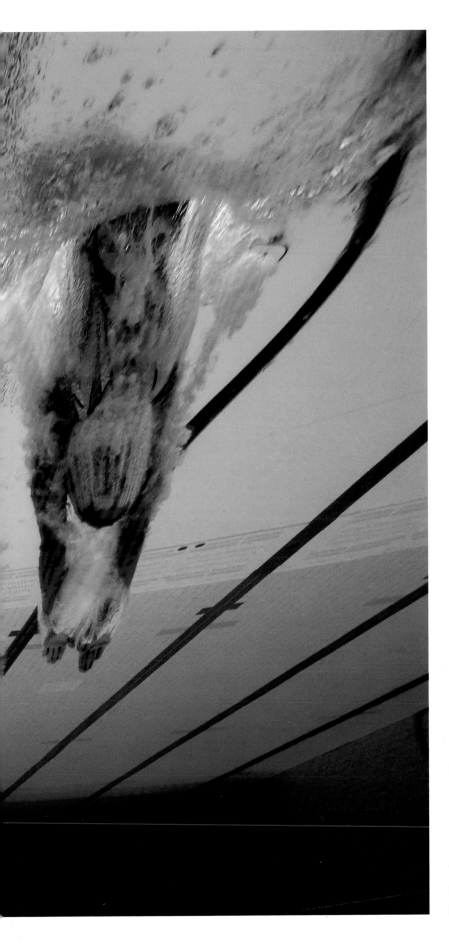

Team GB synchronised swimmers dive into the Aquatics Centre pool during the final free routine, London 2012 Olympics, 10th August 2012.

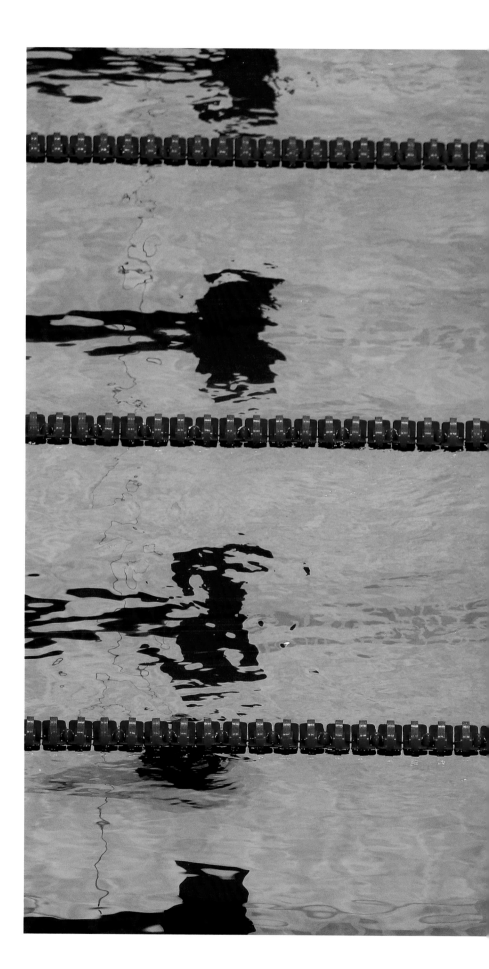

Nyree Kindred of Team GB lines up next to the armless Chinese swimmer Lu Dong who won gold in the Women's 100m Backstroke Final setting a new world and paralympic record during the London 2012 Paralympics, 30th August 2012.

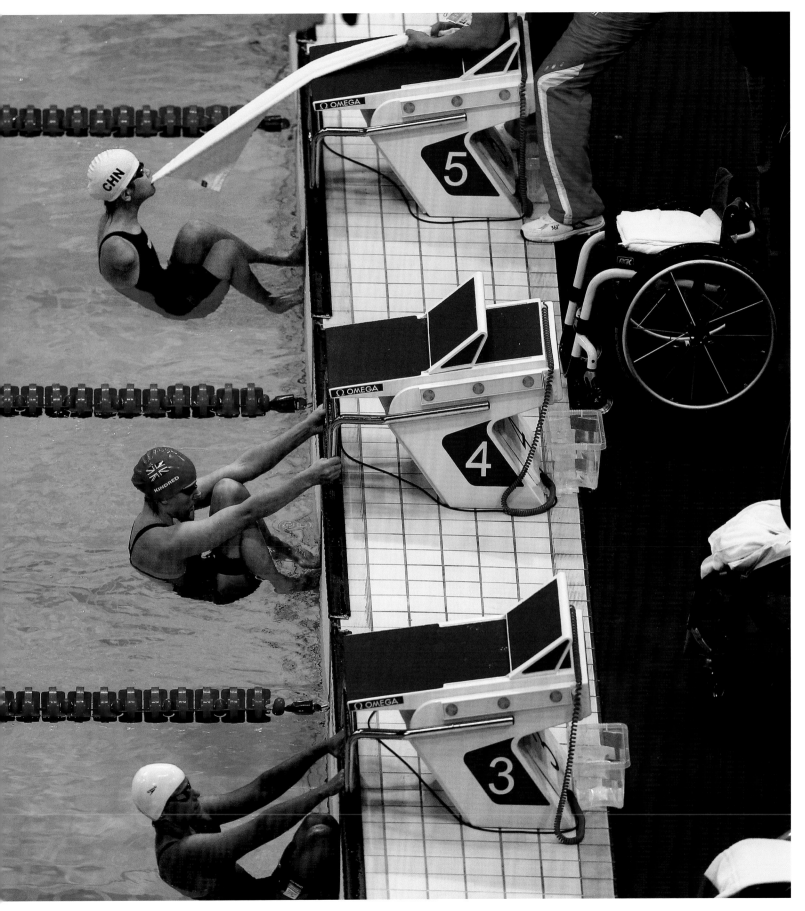

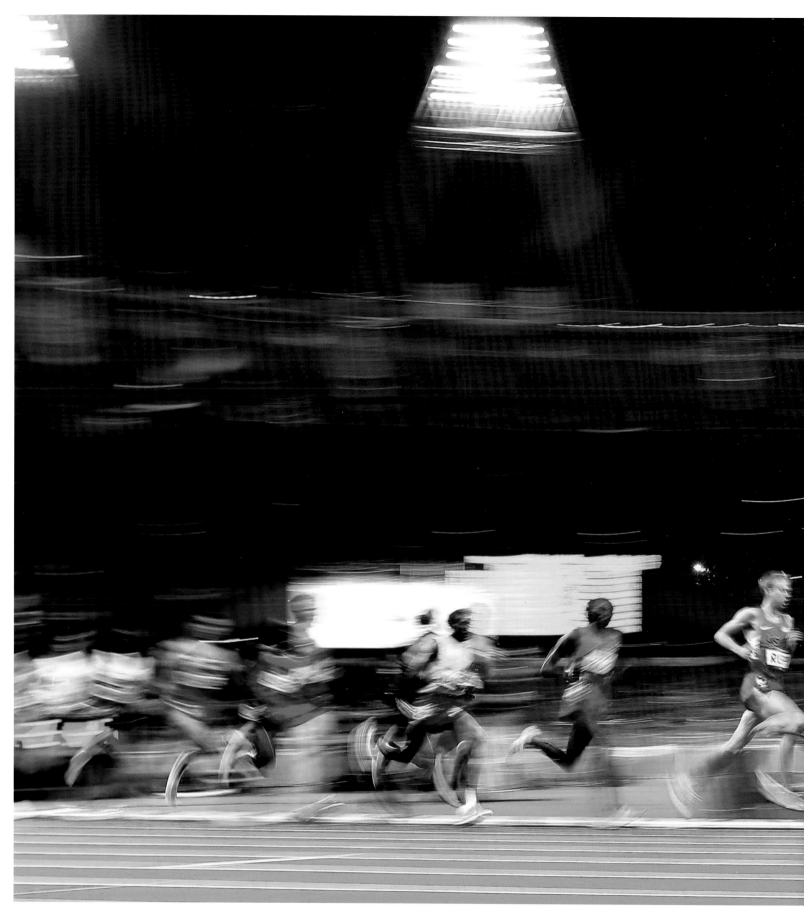

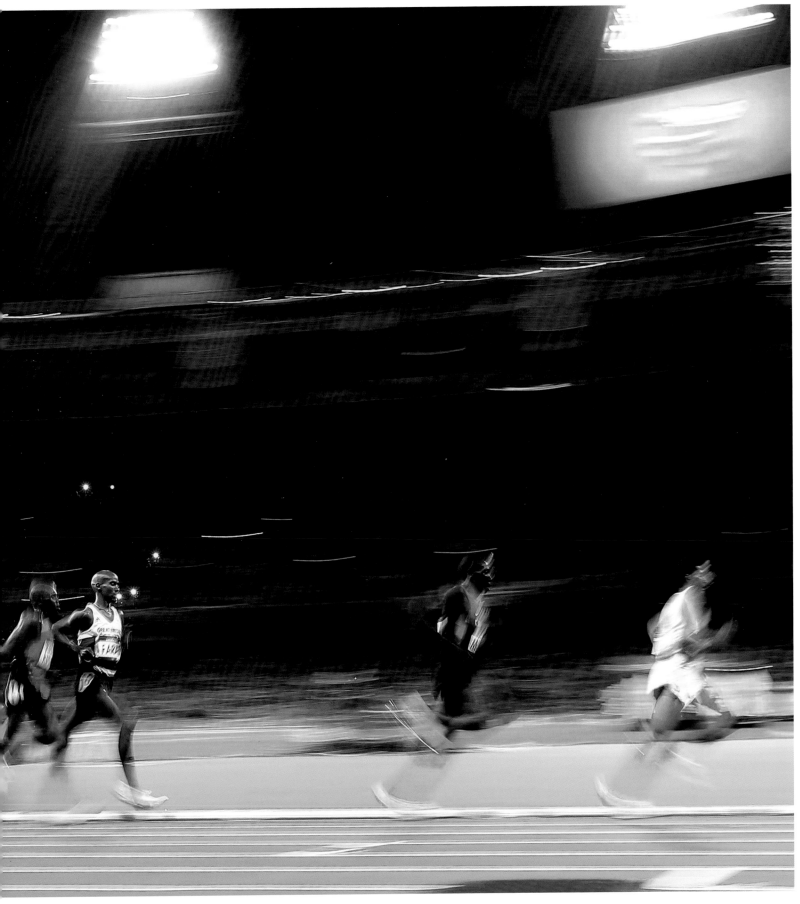

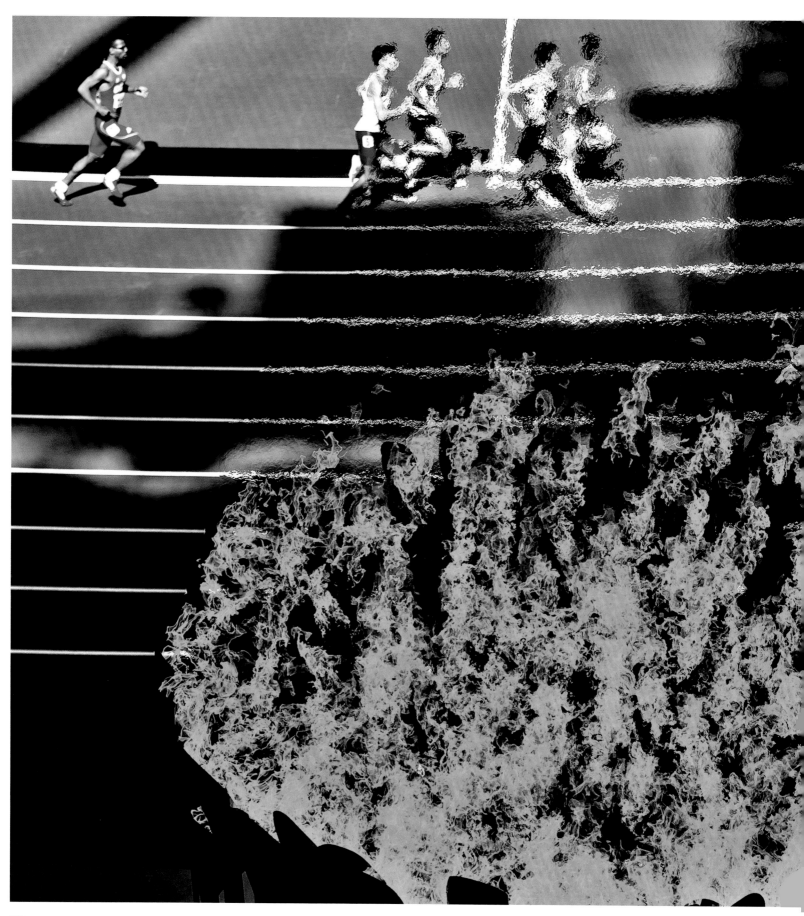

Previous page: Mo Farah of Great Britain wins gold in the Men's 10,000m in the Olympic Stadium, London, 27th July 2012.

Opposite: Contestants take to the track in front of the Olympic flame at the London Paralympics, 30th August 2012.

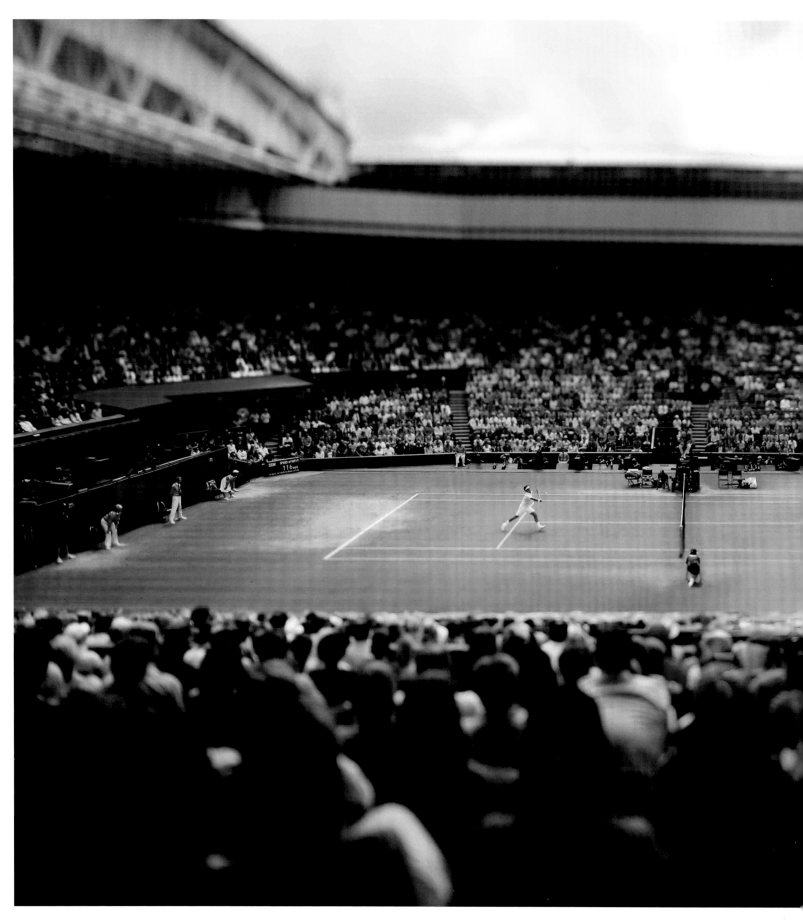

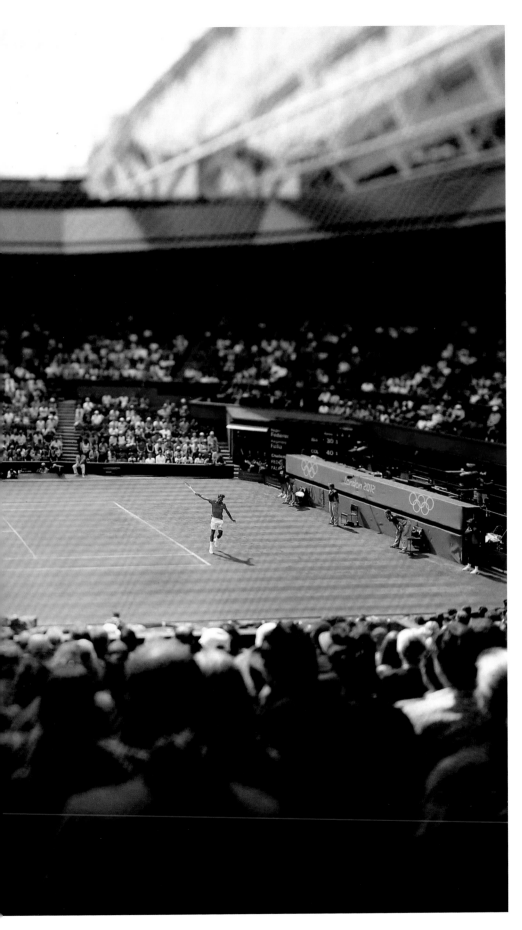

The Times were given unprecedented access by the All England Lawn Tennis and Croquet Club (AELTC) during the Wimbledon Championships 2012 to photograph a view of Centre Court decked out in its traditional colours during Roger Federer's semi-final match against Novak Djokovic. Then, The Times were again allowed exclusive access to photograph the champion competing less than one month later during his first round match at the London 2012 Olympics with the historic Centre Court this time dressed in the Olympic colours. The two images were 'stitched' together to show Roger Federer playing himself on Centre Court at Wimbledon, July 2012.

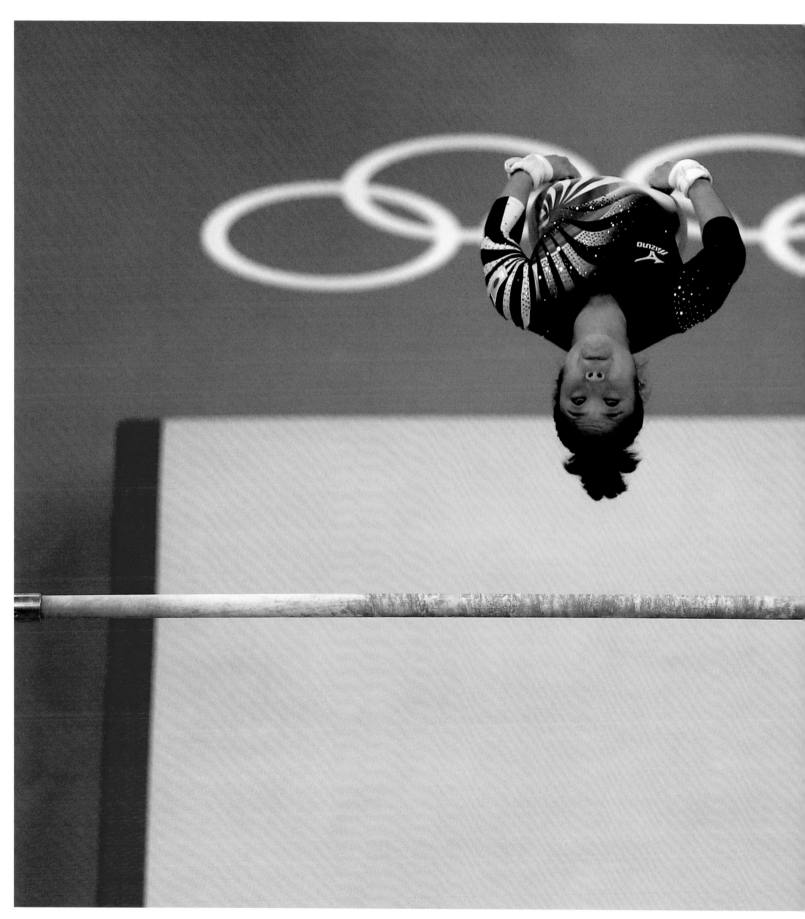

Koko Tsurumi of Japan competes on the uneven bars in the artistic gymnastics finals during the London 2012 Olympics. 27th July 2012.

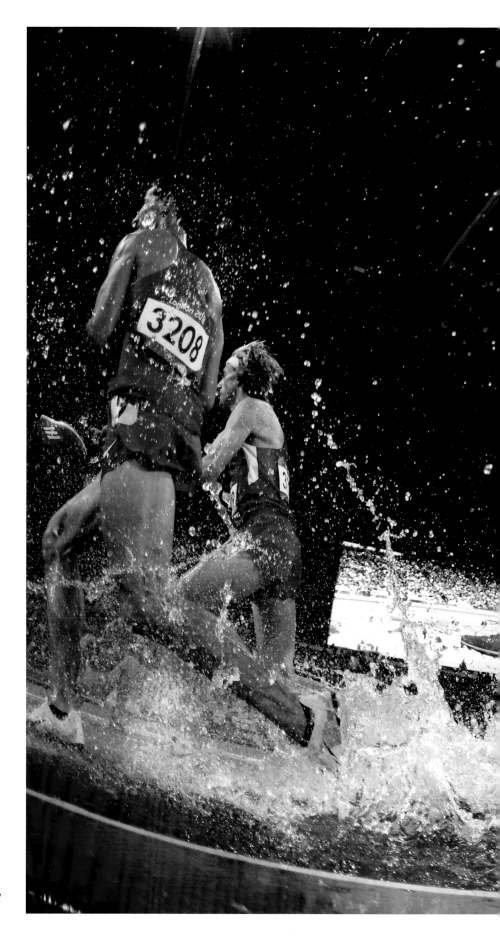

Silver medallist Mahiedine Mekhissi-Benabbad of France seems to hold hands with fellow competitor Hamid Ezzine of Morocco, who finished seventh in the Men's 3000m Steeplechase final at the 2012 Summer Olympics, London, 5th August 2012.

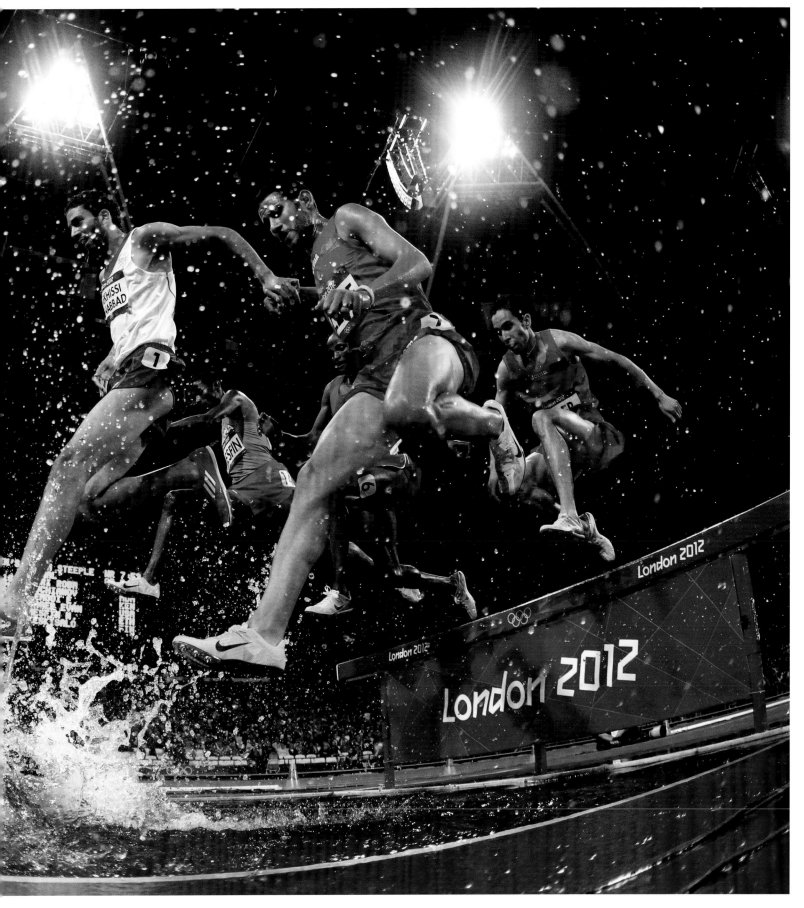

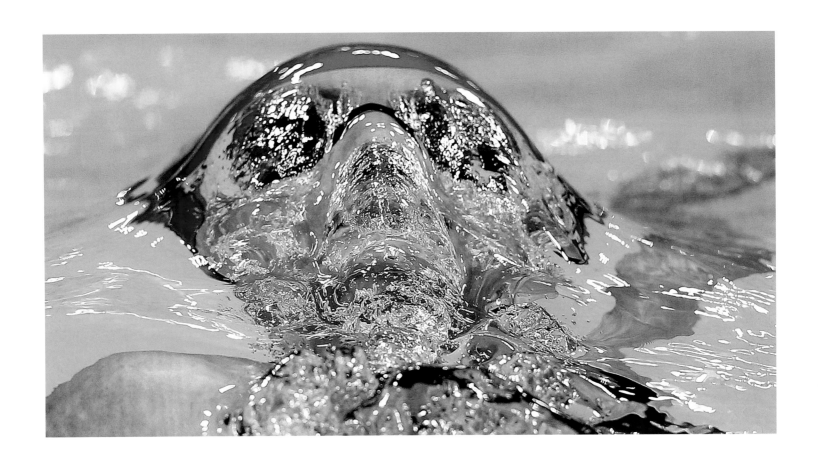

Gemma Spofforth of Great Britain in the Women's 100m Backstroke final at the Aquatics Centre, 2012 Summer Olympics, London, 1st August 2012.

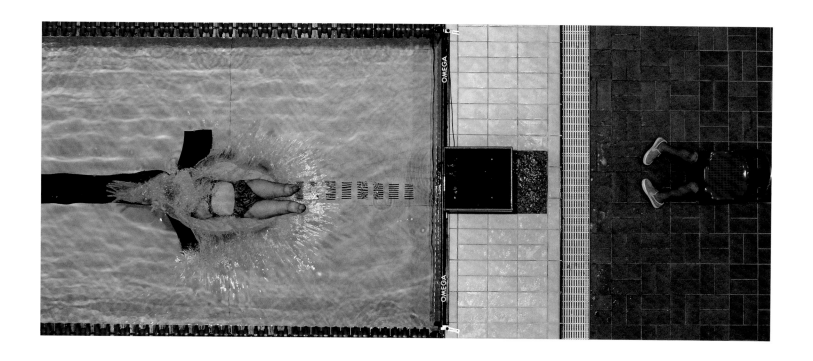

The extraordinarily determined fifteen-year-old Jessica Long, born in Irkutsk, Siberia with deformed legs was adopted aged one by her American parents is seen here training at the Manchester Aquatics Centre, England, 5th May 2007.

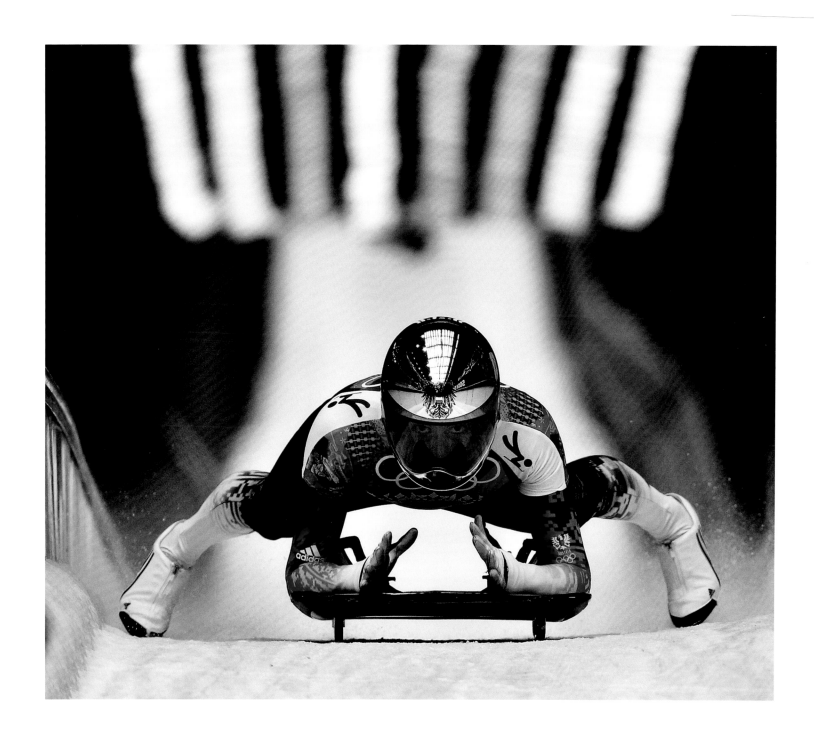

Austrian competitor Janine Flock finishes her final run in the Women's Skeleton at the Sanki Sliding Centre, Winter Olympics, Sochi, 14th February 2014.

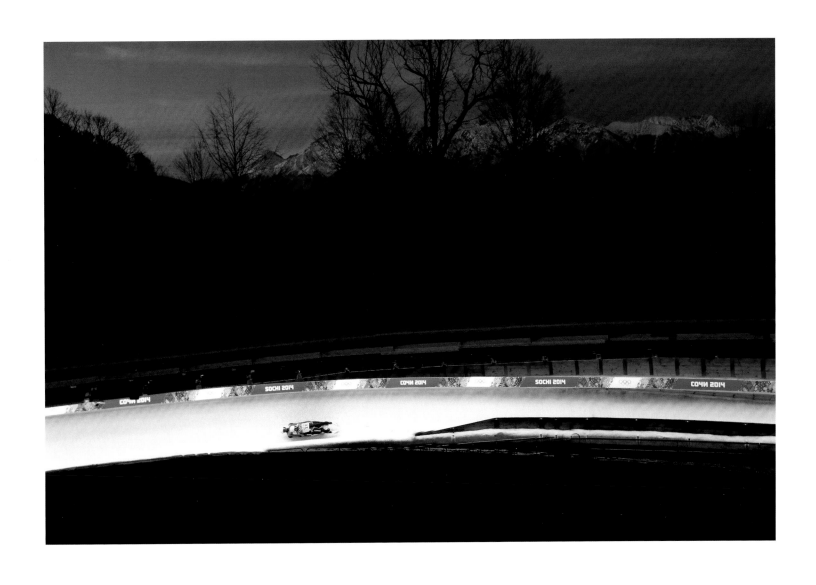

Latvian team of Oskars Gudramovics and Peteris Kalnins take part in the Men's Double Luge competition at the Sanki Sliding Centre, XXII Olympic Winter Games, Sochi, 12th Feburary 2014.

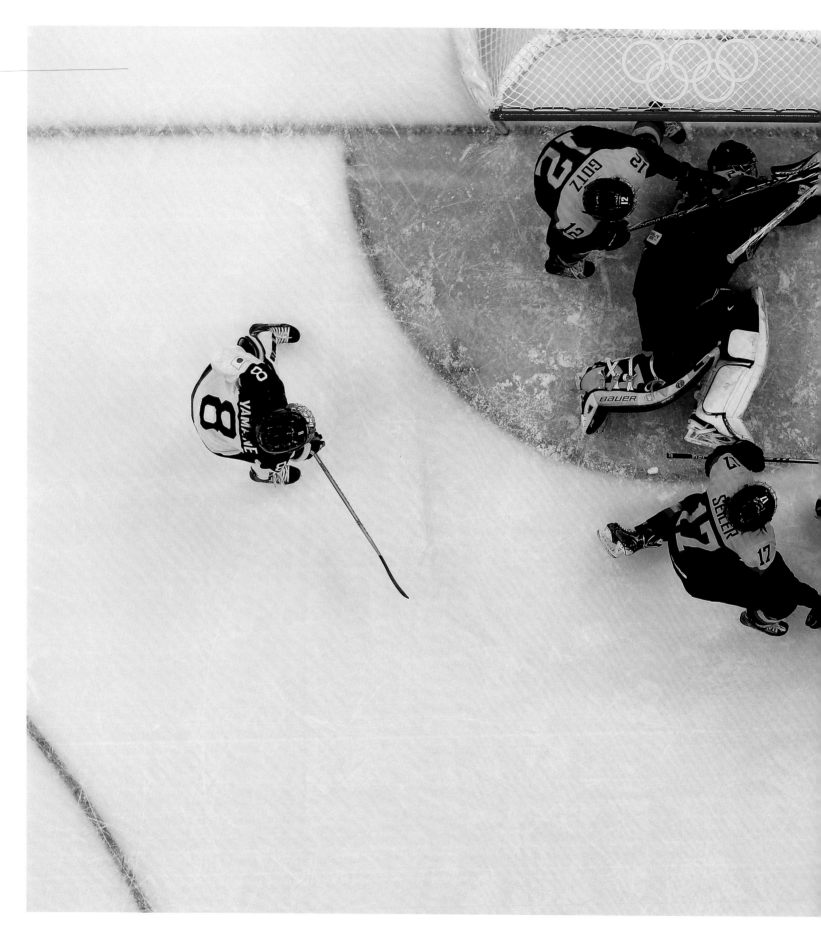

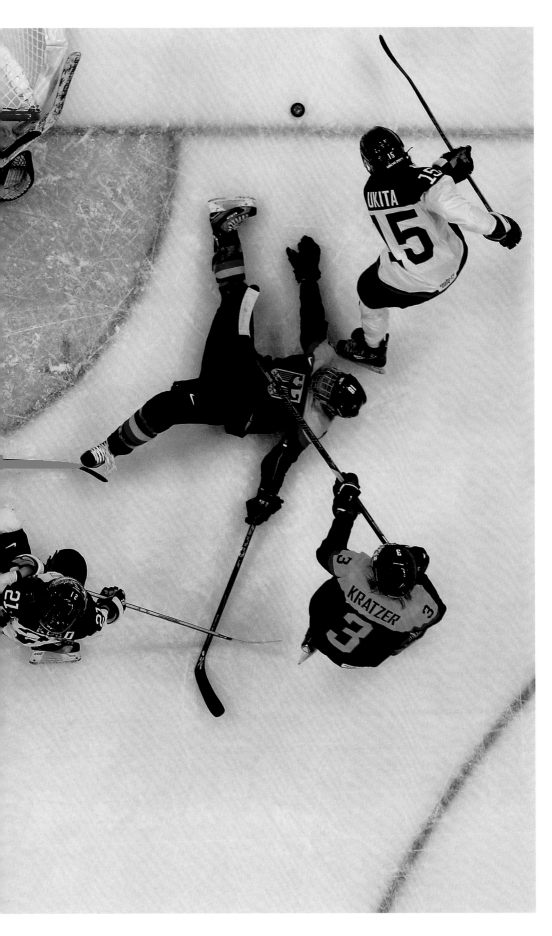

The puck rebounds off the post as Germany goalkeeper Viona Harrer helps her team to a 3-2 win, making a superb blocking save from a lunging strike by Rui Ukita of Japan in the frantic closing seconds of the Women's Team Ice Hockey at the Shayba Arena, XXII Olympic Winter Games, Sochi, 18th February 2014.

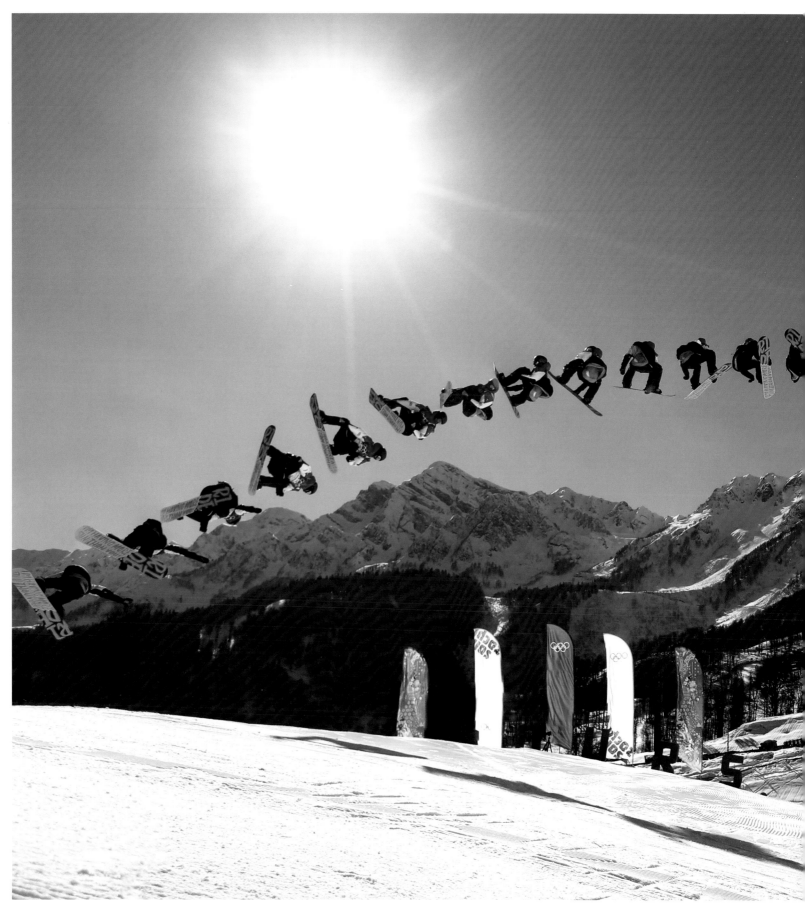

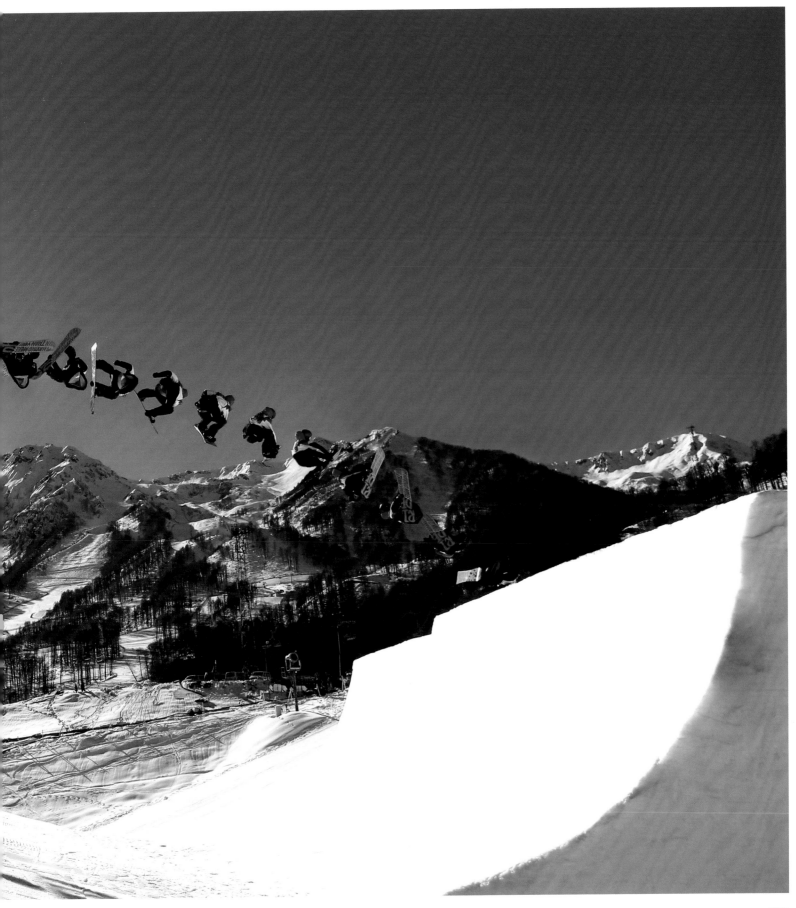

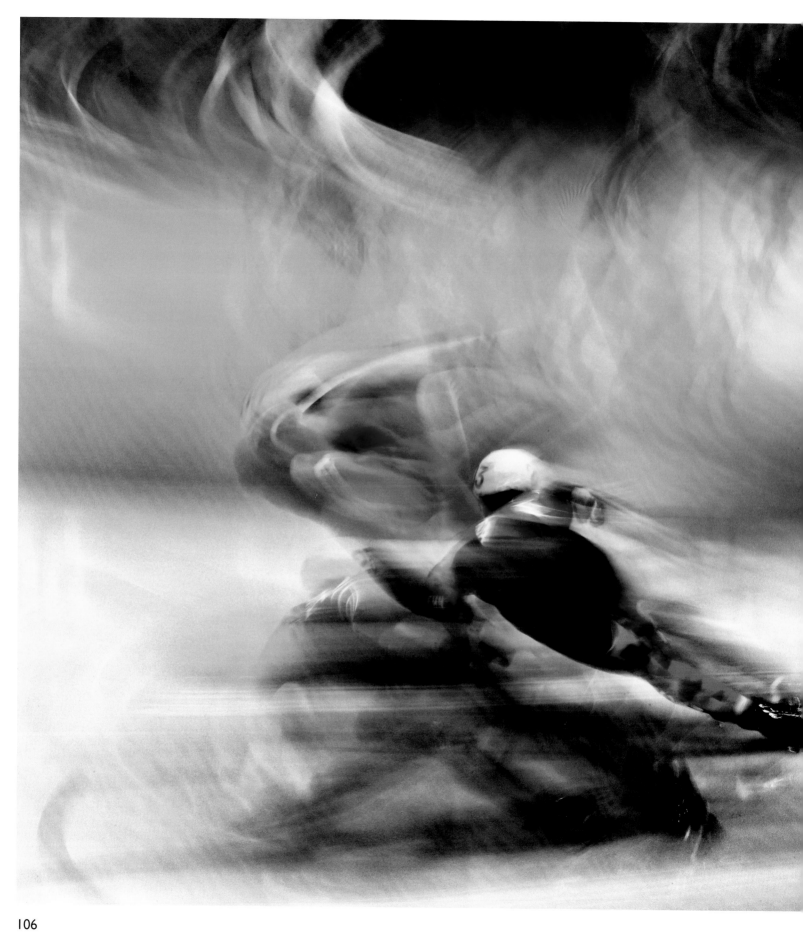

Previous page: Billy Morgan produces an enormous 'air' against the backdrop of the Rosa Khutor Extreme Park at the XXII Olympic Winter Games, Sochi, 8th February 2014.

Opposite: Using settings ISO 400 at f32 for 0.3 seconds to convey the intense speed and beautiful colours of the Ladies Short Track 1000m speed skating final at the Iceberg Skating Palace, XXII Olympic Winter Games, Sochi, 21st February 2014.

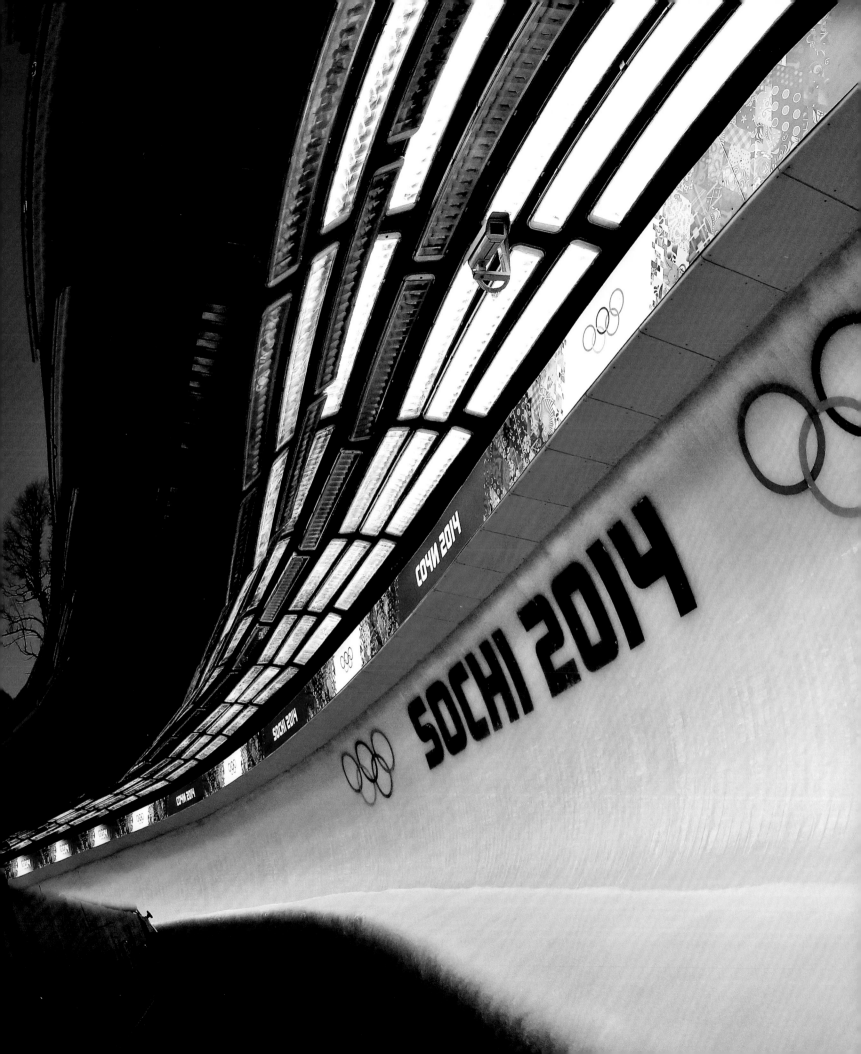

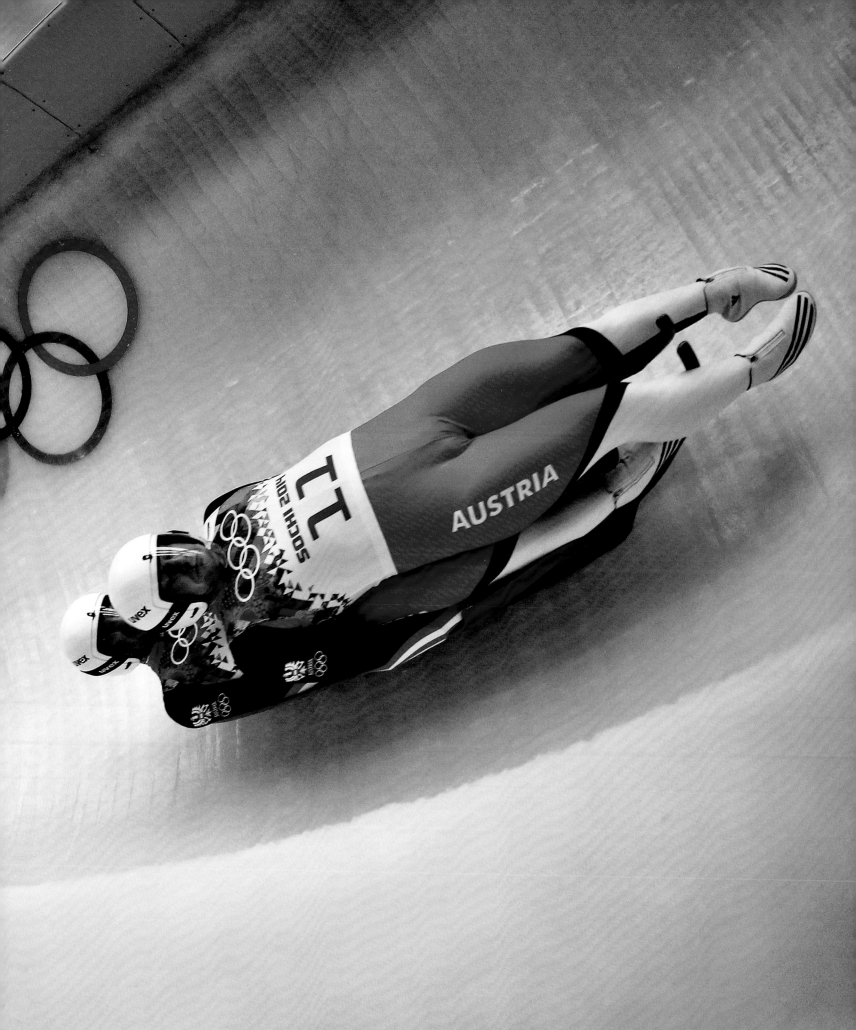

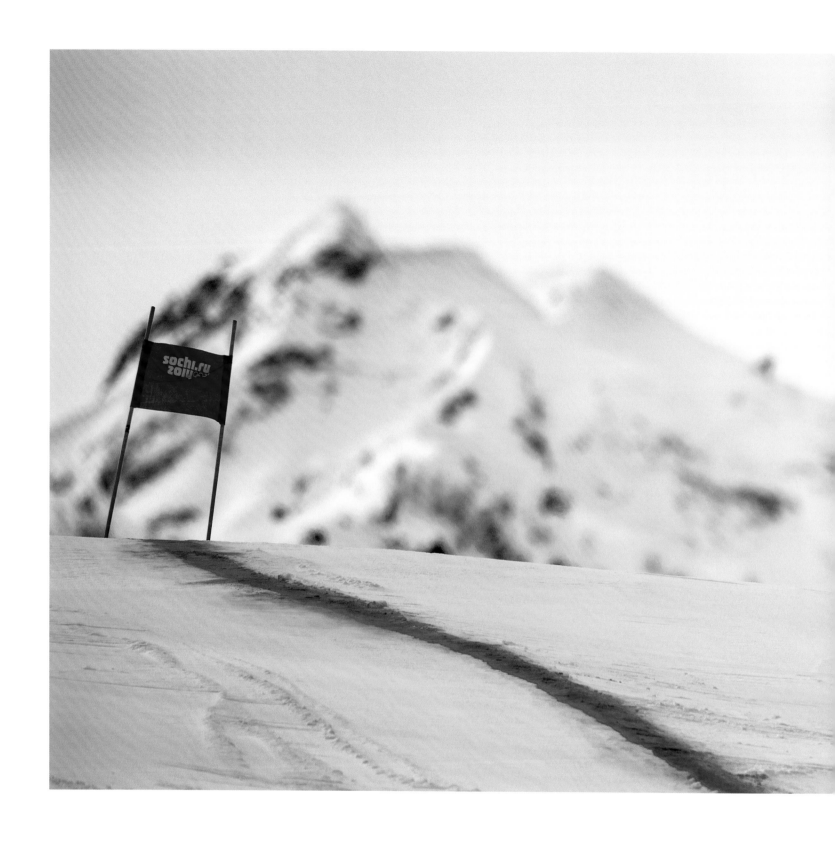

Russian pair Dimitri Soloviev and Ekaterina Bobrova during the Figure Skating Gala at the Iceberg Skating Palace, XXII Olympic Winter Games, Sochi, 22nd February 2014.

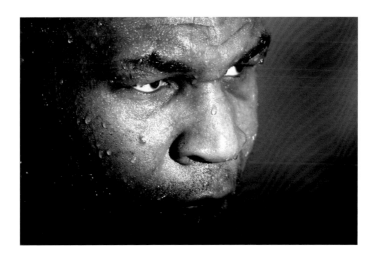

Above: Mike Tyson works out during a training session at the
Grovesnor House Hotel in London before meeting Britain's Julius
Francis at the M.E.N. Arena in Manchester. Tyson knocked Francis
down five times before being awarded a knockout victory in the
second round, 25th January 2000.

Opposite: Andy Murray photographed in London, 16th June 2009.

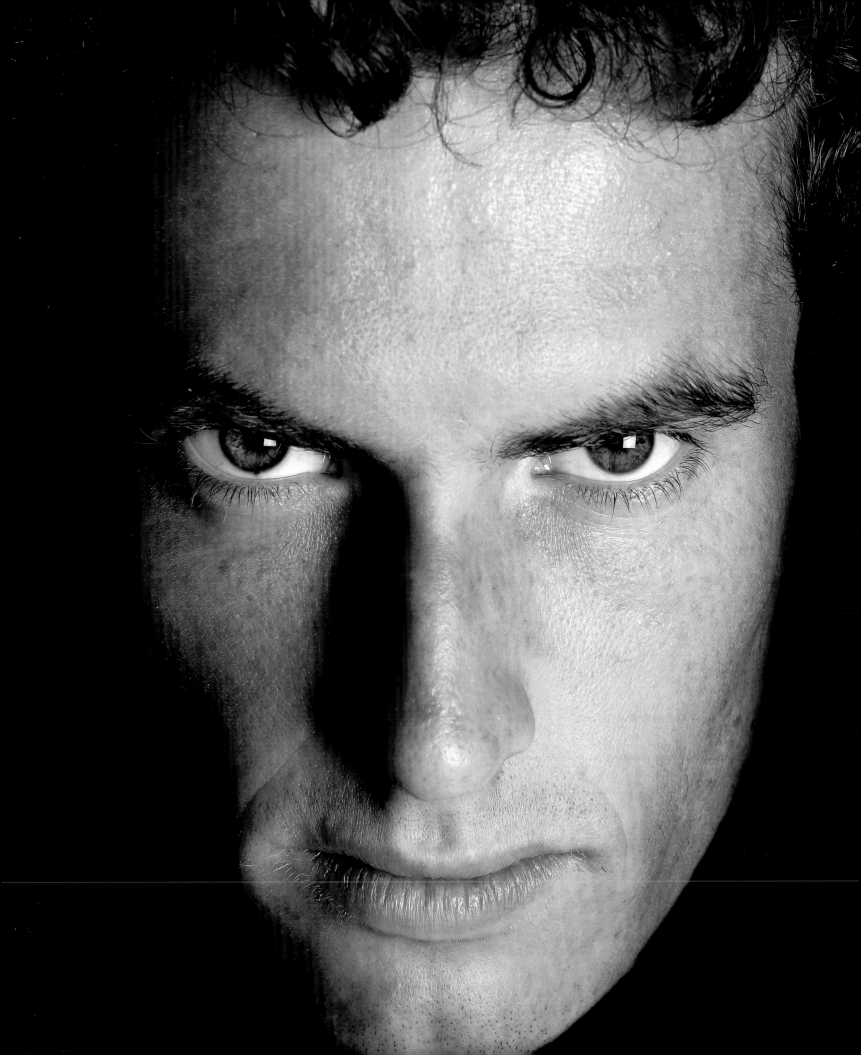

Sprinter Dwain Chambers holds his two week old son Rocco Star Chambers, London, 11th November 2008.

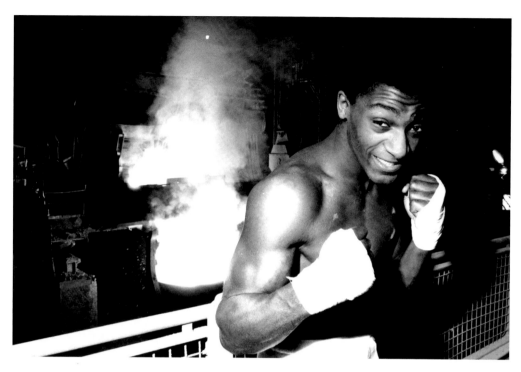

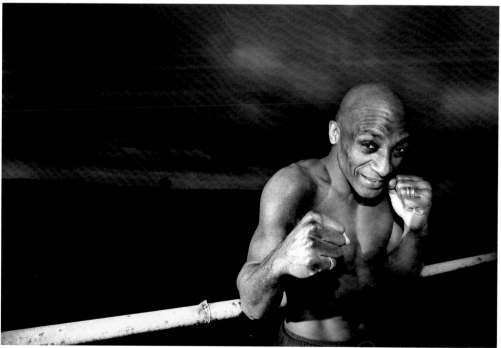

Top: Herol ' Bomber' Graham, photographed in a Sheffield steel mill, 24th September 1984.

Bottom: Forty-seven year-old Graham strikes the same pose twenty-two years later in the spot where the steel mill once stood, 18th December 2006.

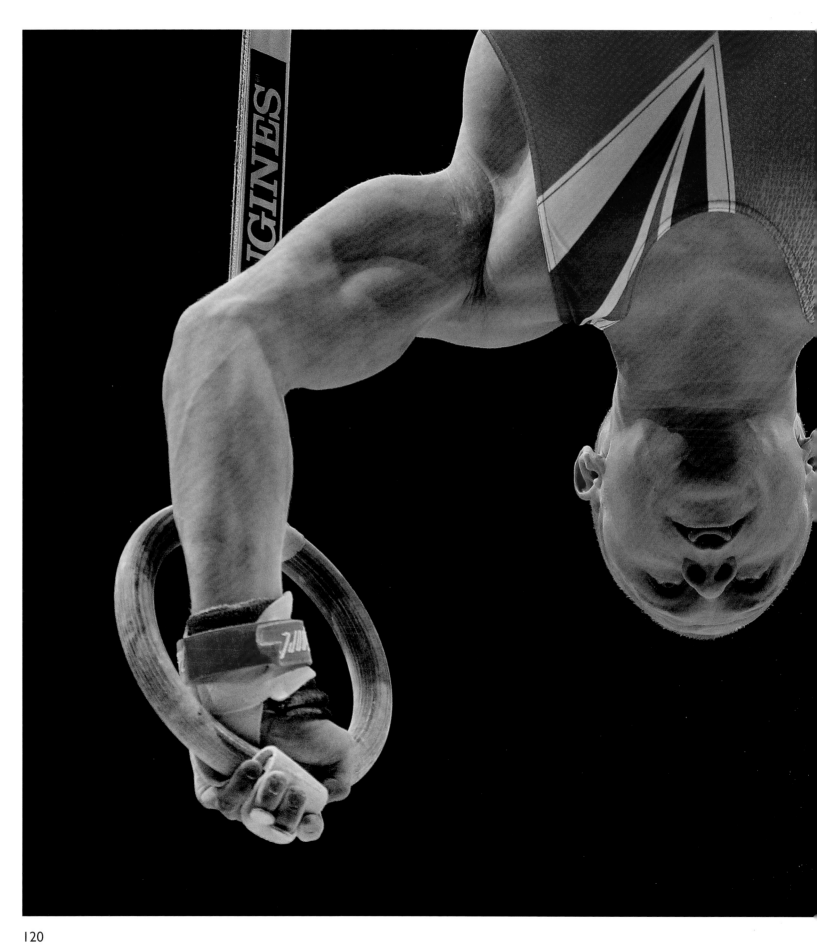

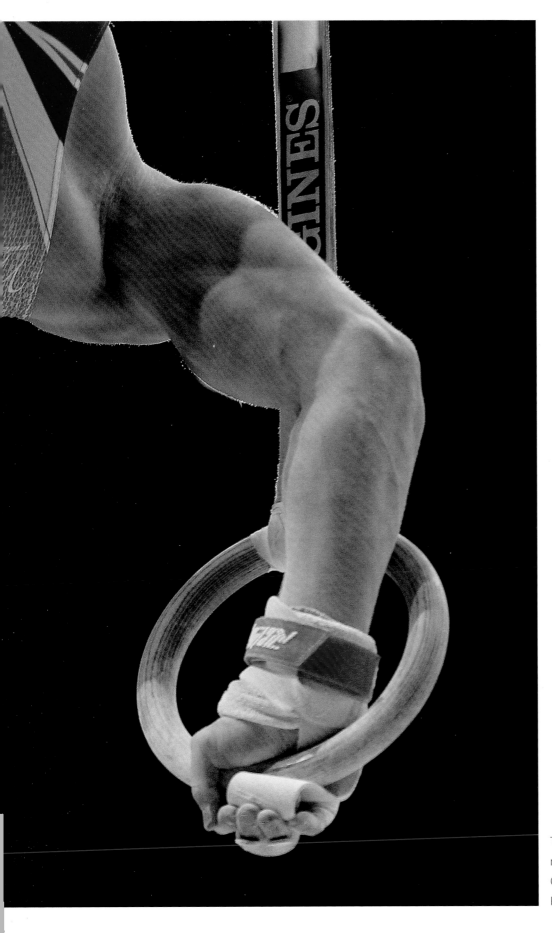

Theo Seager of Team GB during the final of the men's team competition at the World Artistic Gymnastics Championships at the Ahoy Arena, Rotterdam, Netherlands, 22nd October 2010.

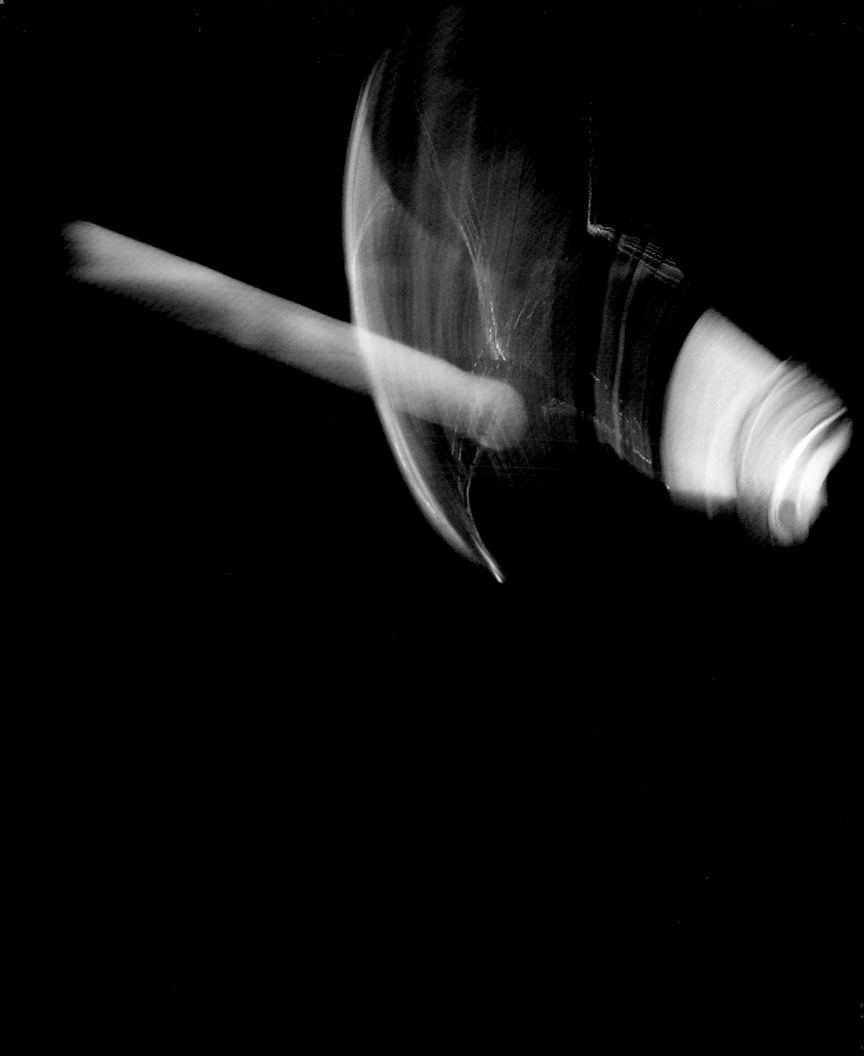

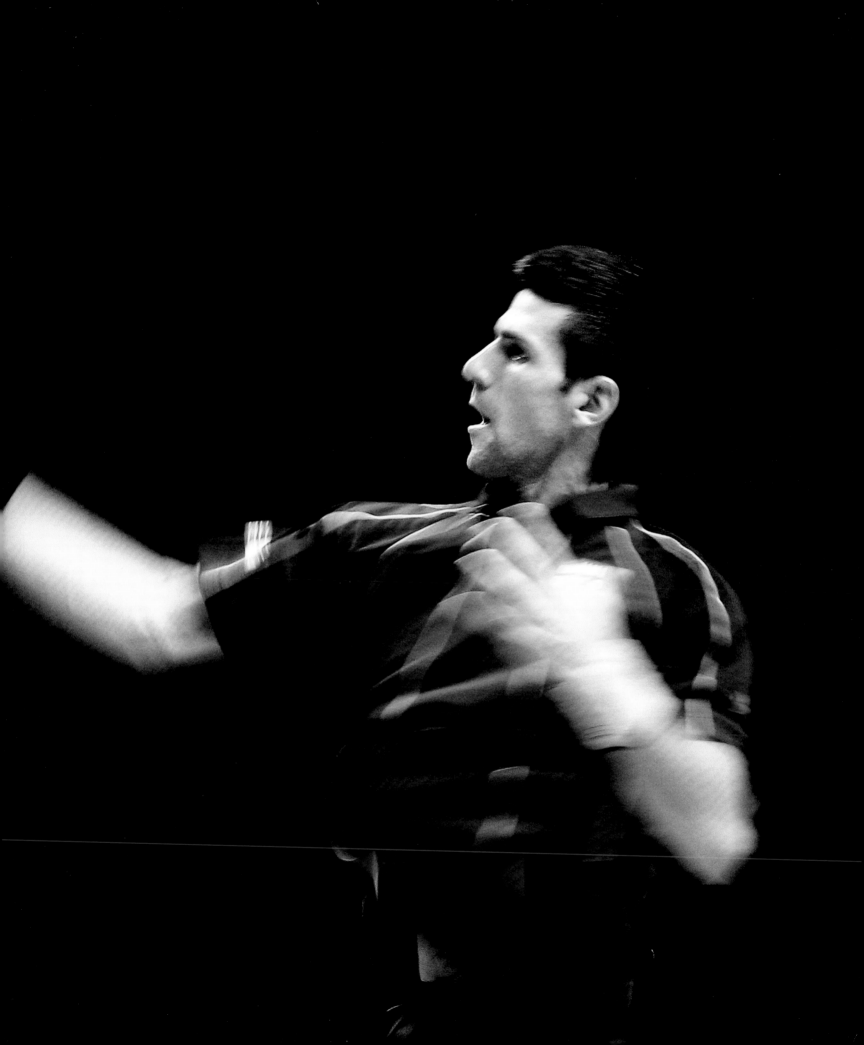

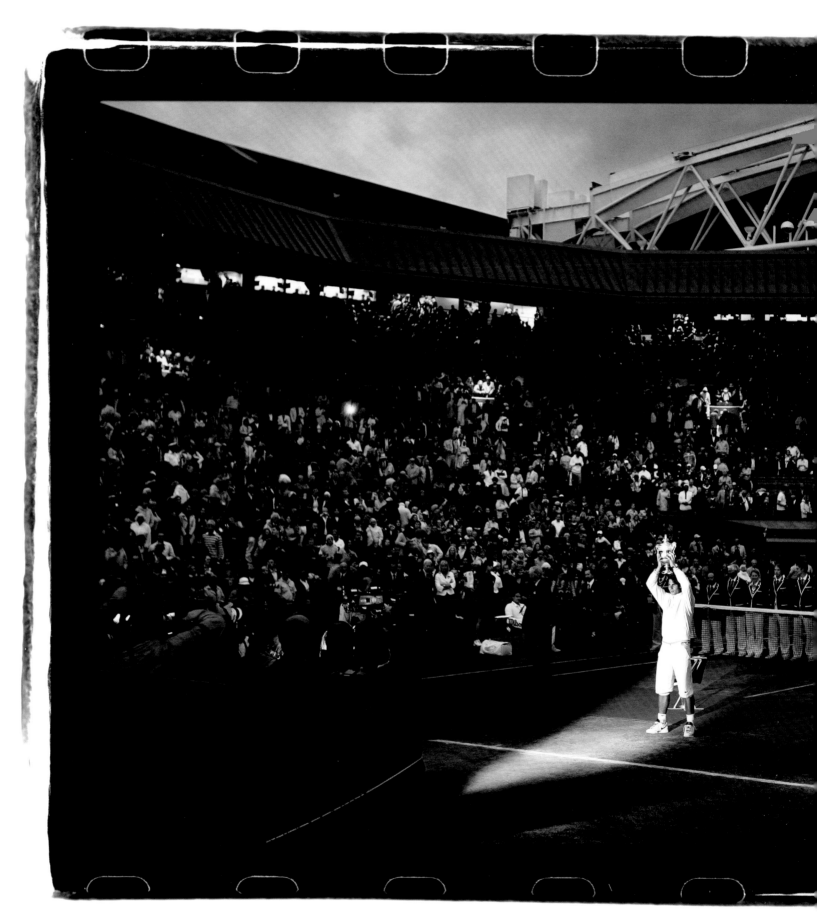

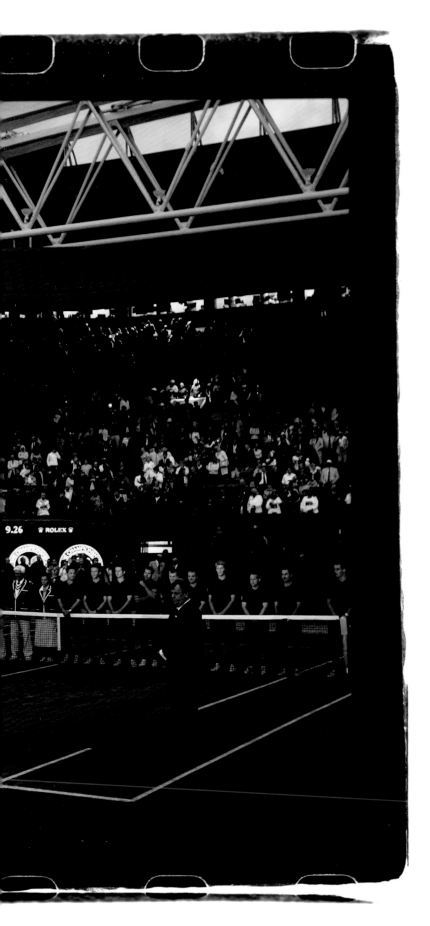

Previous page: Novak Djokovic on his way to a 6-3, 6-4 straight sets victory against Rafa Nadal in the ATP World Tour Final at the O2 Arena, London, 11th November 2013.

Note: The next five images (featuring a border) form a series of photographs of Wimbledon 2008 and appear exactly as the did in *The Times* newspaper.

Opposite: A historic moment – it is 9.26pm when Rafael Nadal holds aloft the famous Wimbledon men's singles trophy, having defeated Roger Federer in the last final to be played without a roof and the longest final in history at the All England Lawn Tennis Club, Wimbledon, 7th July 2008.

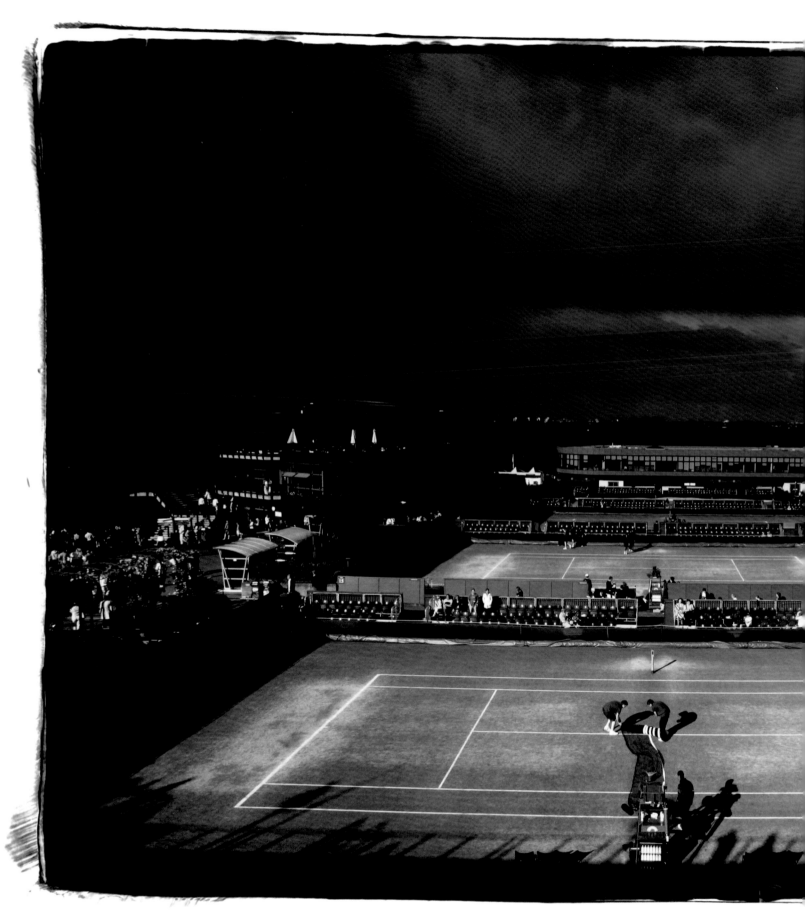

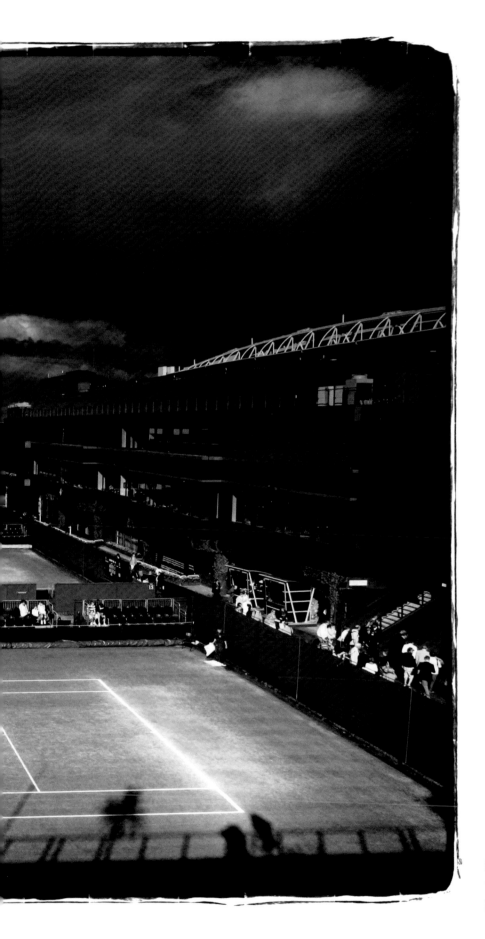

Beneath lowering skies, the nets are prepared on courts 14 and 15 after a typical summer downpour in Southwest London, Wimbledon, 3rd July 2008.

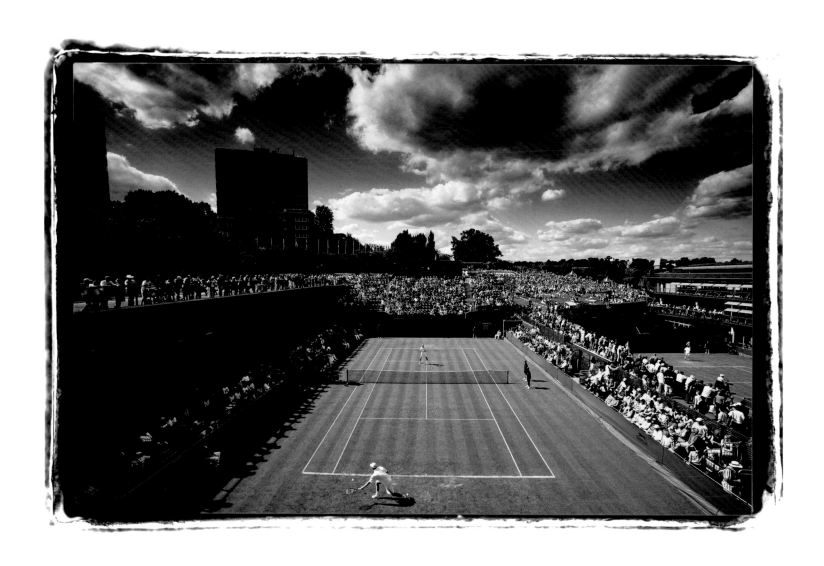

Afternoon action on court 18 at the Wimbledon Championships, 26th June 2008.

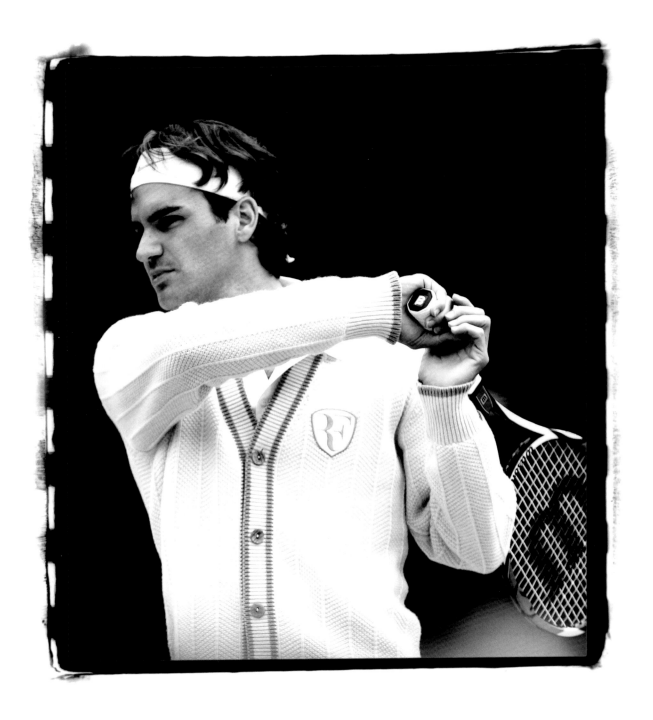

Five-time champion Roger Federer cuts a dash sporting a monogrammed cardigan and white bandana during a warm-up. His elegant attire did not help him to a sixth title. He went on to lose to Nadal in the final. Wimbledon Championships, London, 2nd July 2008.

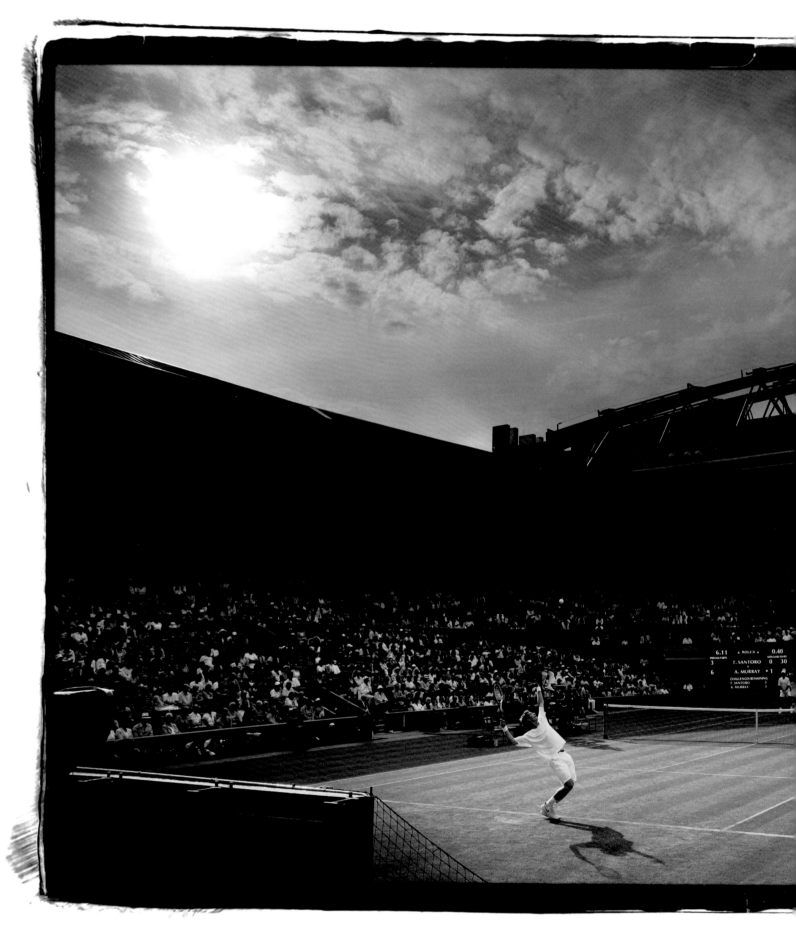

Andy Murray serves against Fabrice Santoro under hazy skies in London SW17 at the Wimbedon Championships, 26th June 2008.

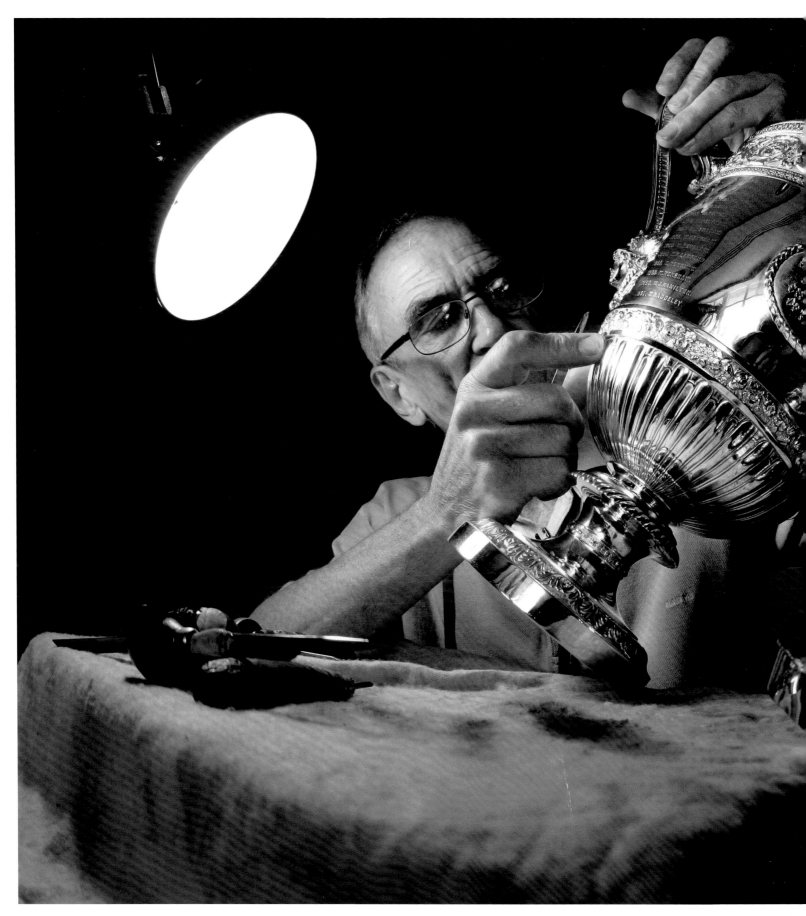

Sixty-seven year old Roman Zoltowski has been the official engraver of both Men's and Women's trophies at the All England Lawn Tennis Club since 1979. He used to live locally, but since moving back to his native Poland, he has driven his red, open-top 1942 MG all the way from Poznan to Southwest London especially to engrave the trophy, Wimbledon, 1st July 2005.

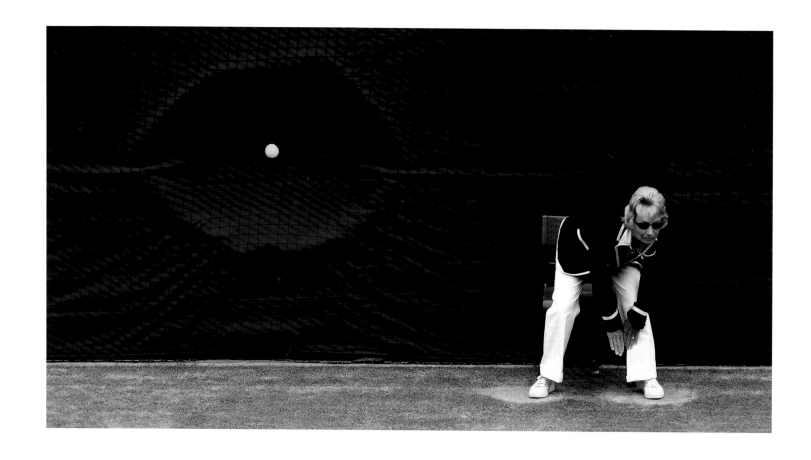

A 'kiss' is formed in the backdrop as Andy Roddick of the United States produces a high-speed serve against Roger Federer in the Men's Singles Final, Centre Court, Wimbledon, 5th July 2009.

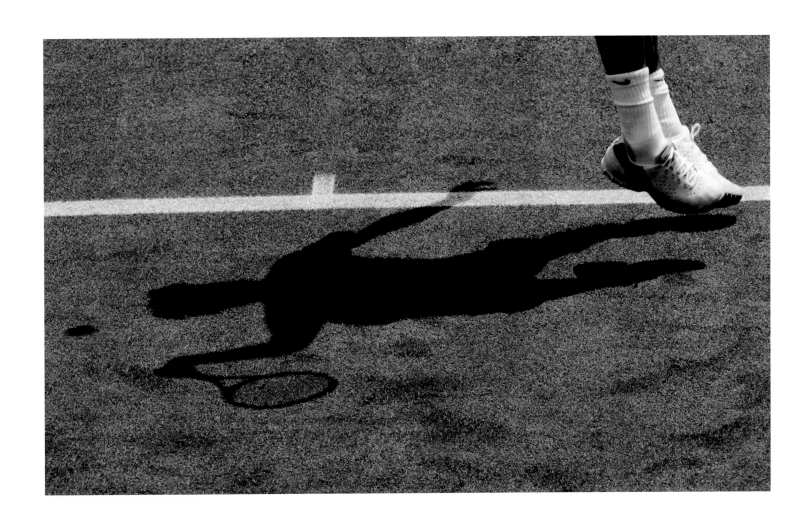

Switzerland's Roger Federer in action against France's Paul-Henri Mathieu at the Wimbledon Championships, 20th June 2005.

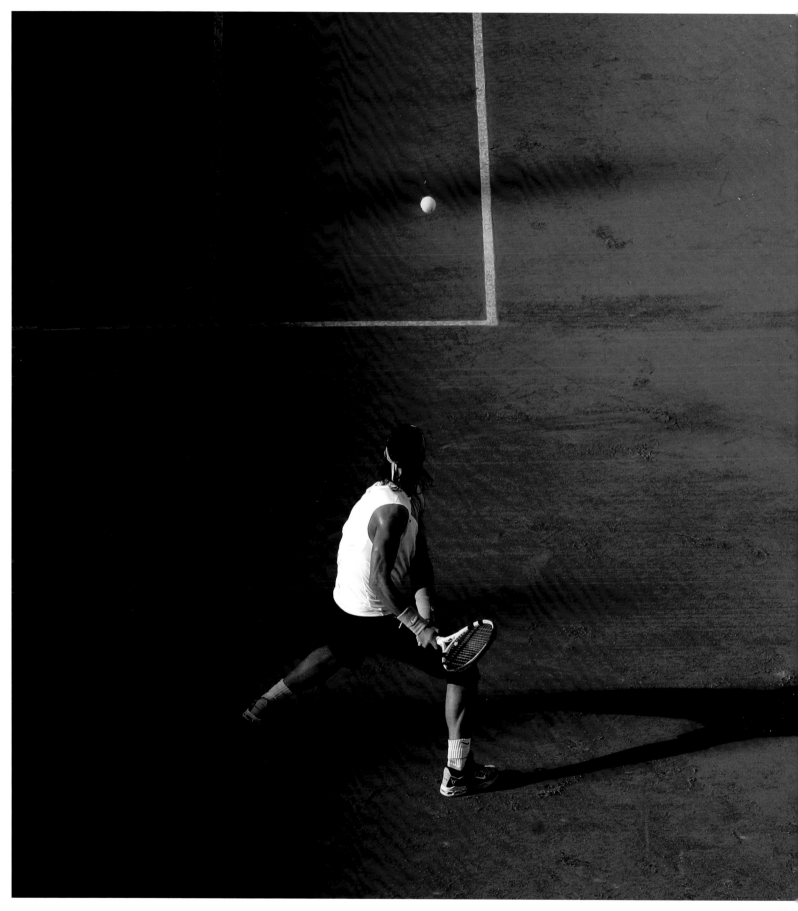

Spain's Rafael Nadal on his beloved clay
against Juan Martín del Potro of Argentina
in the French Open at Roland Garros. Paris,
France, 29th May 2009.

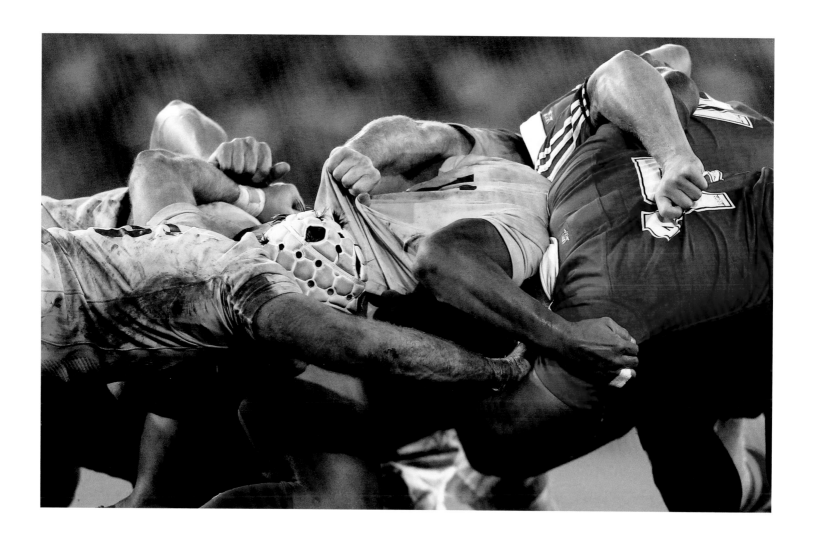

The British and Irish Lions go head-to-head with Australia in the Second Test match at the Etihad Stadium in, Melbourne, Australia, 29th June 2013. The Wallabies sealed victory by the narrowest of margins 16-15.

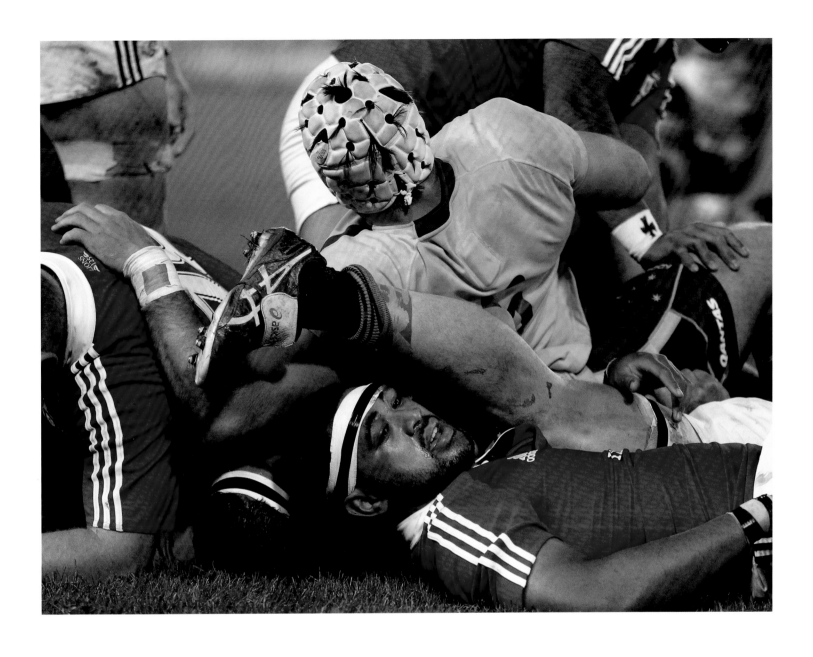

The British and Irish Lions against Australia in the, first test match,at the Suncorp Stadium, Brisbane, 22nd June 2013. The Lions won this one 23-21.

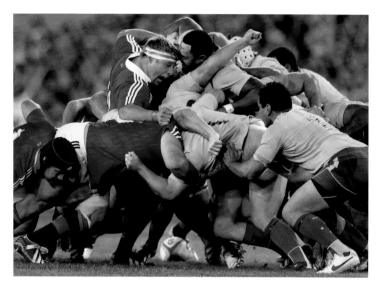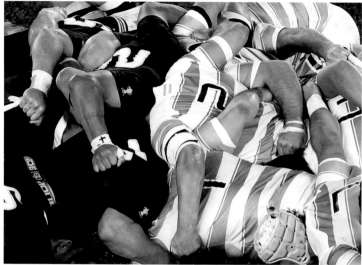

Top left: The British and Irish Lions play Australia in the Third Test at the ANZ Stadium, Sydney, 6th July 2013. The Lions thrashed the Wallabies by 25 points.

Top right: Argentina vs the All Blacks in the Rugby World Cup quarter-final at Eden Park, Auckland, New Zealand, 9th October 2011. The hosts won 33-10.

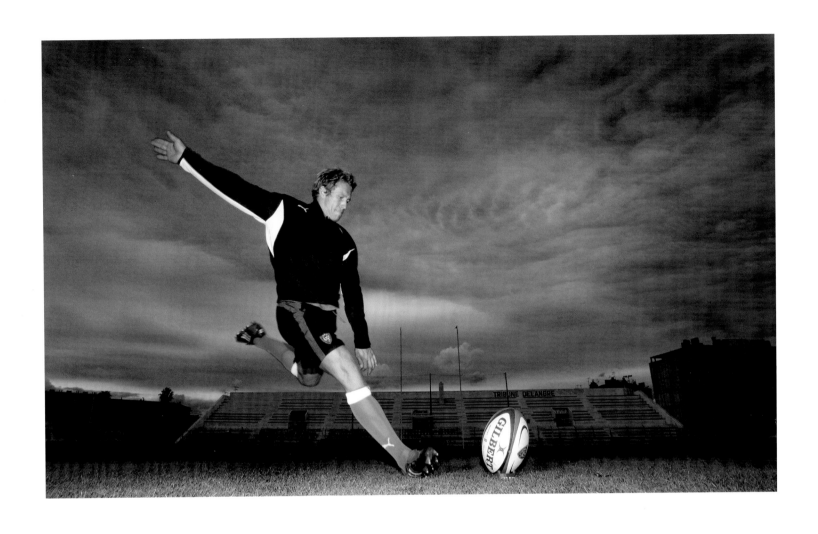

Jonny Wilkinson of Toulon strikes a typical pose at Stade Mayol, France, 20th October 2009.

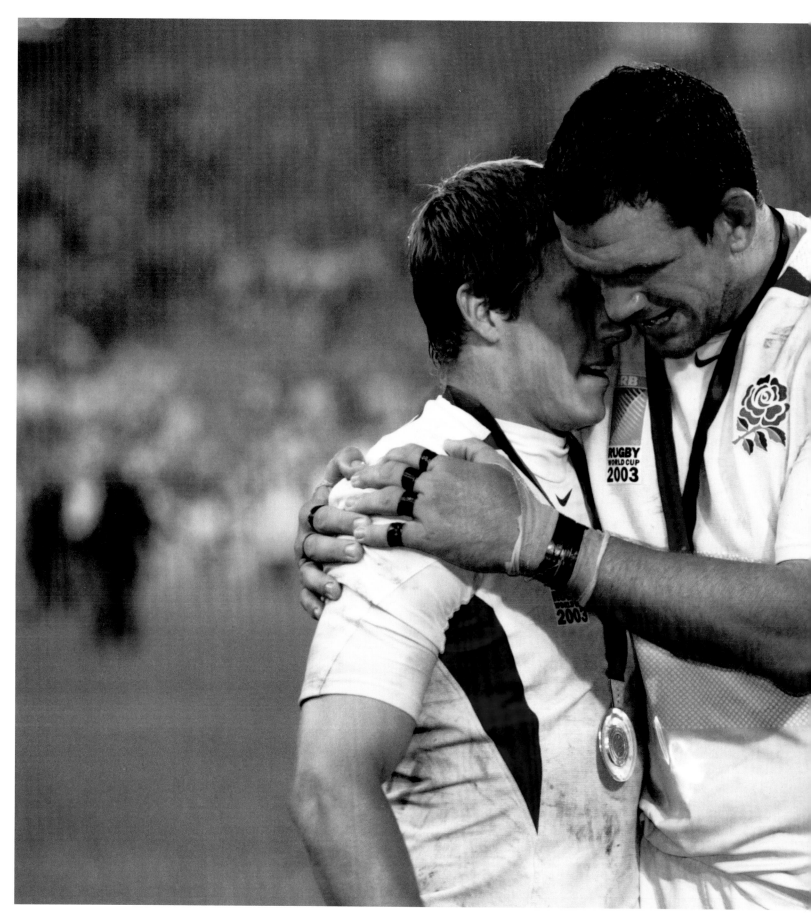

Martin Johnson
England v Australia
22nd November 2003
84th Cap

Hero and Captain – Jonny Wilkinson and Martin Johnson share a moment of reflection after victory in the Rugby World Cup Final against Australia at the Olympic Stadium, Sydney, 22nd November 2003.

Cover: The 101st running of 'White Turf', St Moritz, Switzerland, 2008.

Prestel Verlag, Munich
A member of Verlagsgruppe Random House GmbH

Prestel Verlag
Neumarkter Strasse 28
81673 Munich
Tel. +49 (0)89 4136-0
Fax +49 (0)89 4136-2335

www.prestel.de

Prestel Publishing Ltd.
14-17 Wells Street
London W1T 3PD
Tel. +44 (0)20 7323 5004
Fax +44 (0)20 7323 0271

Prestel Publishing
900 Broadway, Suite 603
New York, NY 10003
Tel. +1 (212) 995-2720
Fax +1 (212) 995-2733

www.prestel.com

Library of Congress Control Number is available; British Library Cataloguing-in-Publication Data: a catalogue record for this book is available from the British Library; Deutsche Nationalbibliothek holds a record of this publication in the Deutsche Nationalbibliografie; detailed bibliographical data can be found under: www://dnb.d-nb.de

Prestel books are available worldwide. Please contact your nearest bookseller or one of the above addresses for information concerning your local distributor.

Editorial direction: Lincoln Dexter
Design and layout: Michael English
Production: Friederike Schirge
Origination: Reproline Genceller, München
Printing and binding: Neografia, a.s.

Printed in Slovakia

Verlagsgruppe Random House FSC® N001967

The FSC®-certified paper Profisilk has been supplied by Igepa, Germany

ISBN 978-3-7913-8116-9

Acknowledgements

It would be remiss of me not to start at the beginning and acknowledge that I owe the biggest debt of gratitude to my mum and dad for their love and support. For Bob Ingram for lending me a 35mm SLR camera to snap away on a trip to the 24 Hours of Le Mans. Mr Paul Delmar at the National Council for the Training of Journalists (NCTJ) in Sheffield, who has nurtured and guided the raw talent of generations of fine photojournalists. At my first newspaper being a Junior Photographer at the *Watford Observer*, I had the ever-patient Mike Dellow as the best mentor a young whippersnapper could wish for. After a quantum-career leap I found myself shoulder-to-shoulder with Chris Smith in the darkrooms shared by the awesome photographers of *The Times* and *Sunday Times*. I had studied Chris' work with a religious fervour and to be sharing the same touchline, I could barely say, 'Hello!'.

There have been many great Editors, Sports Editors and Picture Editors I have been blessed to work with at *The Times* and I am grateful to all for their support. I must mention the following for clearly defining both me as a photographer and also my career. The dynamic duo of David Chappell and Keith Blackmore, my first Sport Editors, who taught me very quickly that I had a lot to learn and I hope I have lived up to their high expectations. For Sue Connolly, now Picture Editor at *The Times*, a great friend and even greater boss.

For Mr Tim Hallissey, Sports Editor and his team of editors, sub editors and designers at *The Times* who encouraged me to keep producing the bullets so they could fire them! For James Harding, Jeremy Griffin and Craig Tregurtha. And to those blunts, the scribblers and journos, the Dukes and Grand Dukes who make up the other half of my working life. There are many superb writers – apologies to those not mentioned, but you will know. I must give a special debt of appreciation to Oliver Holt, Matt Dickinson, Simon Barnes, Owen Slot, Paul Hayward, John Hopkins, Rick Broadbent, Oliver Kay, Matthew Syed, Graham Hunter, Neil Harman, Lee Clayton and Mike Atherton.

The most difficult task in compiling this list is the risk of omitting many of the superbly gifted photographers I have shared this amazing journey with. I must however give mention to my fellow newspaper friends: Andy Hooper, Graham Chadwick, Russell Cheyne, Eddie Keogh, Bradley Ormesher, Graham Hughes, Phil Shepherd-Lewis, Michael Powell, Dave Shopland, Mark Robinson, Kent Gavin, Richard Pelham and Stuart Robinson. For all my 'news' colleagues both past and present at *The Times* and to those sports photographers I hold in such high regard: Simon Bruty, Dylan Martinez, Owen Humphreys, David Davies, Adrian Dennis, David Rogers, Shaun Botterill, Mark Thompson, Clive Mason, Alex Livesey, Lawrence Griffiths, Mark Leech, and Bob Martin.

For my friend Jonny Wilkinson – thanks for the fun times!

For the support and generosity of my friends at Canon, specifically, Katie Simmonds, Mike Owen and Frankie Jim. A special thanks to my eternally reassuring agent David Luxton and our friends at Prestel Publishing.

I can proudly hand this book to my children because of the support and dedication of my friend and designer Mike English.

And finally I dedicate this book to Audrey for her unbelievable support, sacrifice and understanding that my job has been my life, but she is my passion.

MUNICH · LONDON · NEW YORK